DIGITAL ART

RENDEROSITY

FOR THE 21ST CENTURY

JOHN GRANT AND AUDRE VYSNIAUSKAS

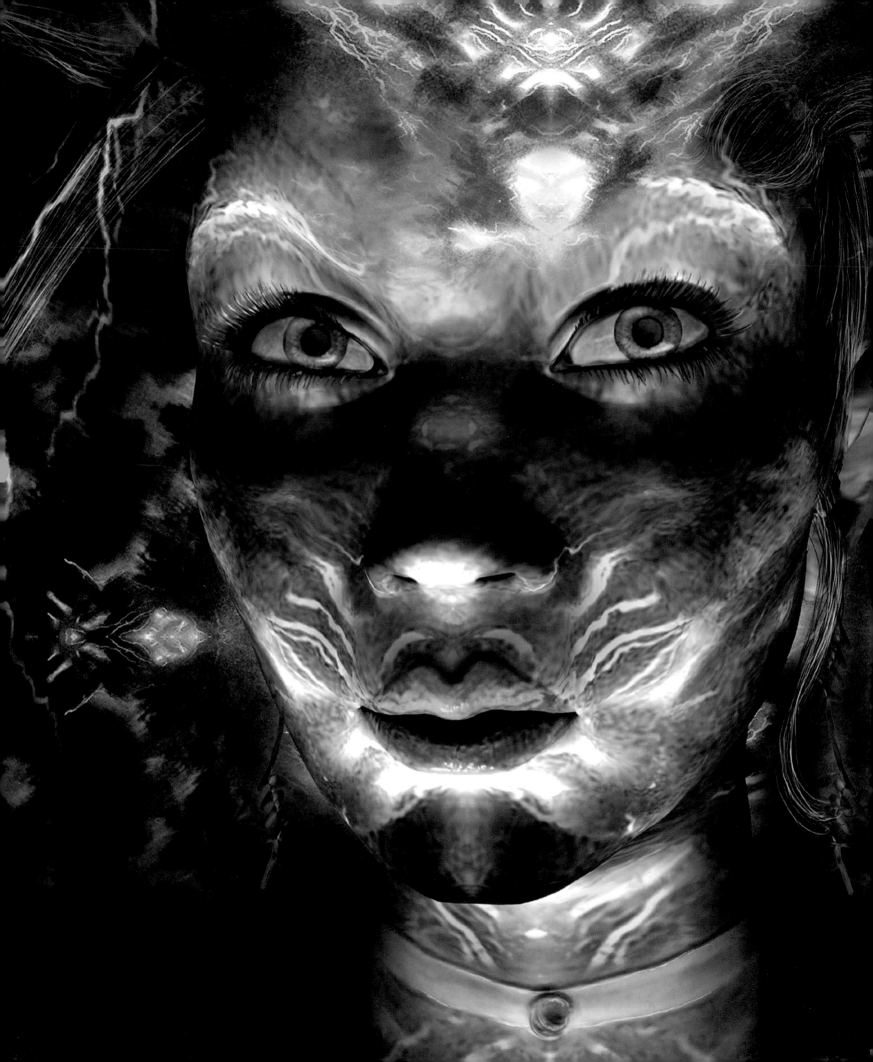

DIGITAL ART
RENDEROSITY
FOR THE 21ST CENTURY

HDi

HARPER
DESIGN
international

An imprint of HarperCollinsPublishers

DEDICATIONS

To Ray, without whose support my escapades into the digital minutiae would not be possible, and to everyone who enjoys and appreciates art in all its myriad forms.

– AV

To Jane and Pam, my *raisons d'être*.

– JG

DIGITAL ART FOR THE 21ST CENTURY
RENDEROSITY

First published in 2004 by:
AAPPL Artists' and Photographers' Press Ltd., London, UK
© 2004 AAPPL
Text copyright © John Grant and Audre Vysniauskas
Copyright in the pictures rests with each individual artist

Distributed throughout the USA and Canada by:
Harper Design International
10 East 53rd Street
New York, NY 10022
Fax: (212) 207-7654

HarperCollins books may be purchased for educational, business, or sales promotional use. For information, please write: Special Markets Department, HarperCollins Publishers Inc., 10 East 53rd Street, New York, NY 10022.

Editor: Paul Barnett
Art Director and Designer: Malcolm Couch

Library of Congress Cataloging-in-Publication Data

Grant, John, 1949-
 Digital art for the 21st century: renderosity / John Grant and Audre Vysniauskas.
 p. cm.
Includes bibliographical references and index.
 ISBN 0-06-073037-4
 1. Digital art. I. Vysniauskas, Audre. II. Title.
 N7433.8.G73 2004
 776--dc22

2003026550

Reproduction and printing by Imago Publishing Ltd. info@imago.co.uk

DIGITAL ART

FOR THE 21ST CENTURY

CONTENTS

INTRODUCTION

To go by Arthur C. Clarke's famous dictum, we are living in a magical age – an age when technology has become sufficiently advanced to be viewed as magic. Certainly this is the case in the visual arts. Today's artists have a freedom to express their visions using tools unimaginable to previous generations.

The power and versatility of the computer make it an amazing resource for creating stunning art in myriad flavours. It can be used to mimic just about any other medium, from oils to watercolours to photographs. In addition, it brings its very own style palette as well, allowing the artist to harness the beauty of mathematics, the symphony of numbers, the complexity and power of fractals. This modern tool allows artists to blend anything in just about any way they can dream.

Much has been written – *uselessly* written! – about the relationship between digital art and 'other' art. It is the conviction of both authors of this book that the debate is a fundamentally wrongheaded one, being based upon a distinction that does not in fact exist. There is no such thing as 'other' art: there is simply art. Artists have always used the best media to hand in expressing their visions, whether that be vegetable dyes on cave walls or the near-bewildering array of hardwares and softwares on display today. While the computer has brought new possibilities and versatilities, fundamentally it is just another medium that the artist of the 21st century can choose to use – among oils, watercolours, acrylics, the airbrush and so on. The important part of the whole equation – the artist – remains unchanged by the choice of medium.

The volume you hold started life as a dialogue between a writer and the artist who'd been commissioned for the cover of his new book. Perhaps 'dialogue' is too dignified a term; 'chatter' might be closer to the mark. It soon became evident to both that the writer knew very little about digital art – shamefully little, bearing in mind that he spent much of his time commissioning, editing and occasionally writing art books. His only consolation was that just about everybody else (including many artists) seemed to know even less.

At approximately the same moment, cover artist and writer smote their separate foreheads. Of course books existed on how to create digital art, but these were of interest only to potential creators; they were unlikely to be picked up by general artlovers. What was needed for people like the writer was a *showcase* – a book to show the enormous range of beauty that artists were creating using digital tools.

Hence this book. Hence, too, the website www.21stcenturydigitalart.com, which you might like to explore as an additional resource. If you wish to be truly overwhelmed by digital images, try www.renderosity.com, where you will find hundreds of thousands of images from artists of every level.

All of these points aside, the most important thing we set out to do was create, in this book, an object of beauty. Thanks to the superb artists who agreed to contribute to it, we think we have succeeded. We hope you will agree.

Adamas
2003
Personal work
4488 pixels x 2362 pixels
*Software and platform: Caligari Truespace 6,
Windows XP*

The discovery of strange worlds, far away.
Today we can only explore these worlds in our
minds, but one day . . .

Nornstone
2003
Personal work
3150 pixels x 2362 pixels
*Software and platform: Caligari Truespace 6,
Windows XP*

I like to read the fables and myth of ancient cultures.
Here I linked some aspects of the Nordic sagas to
the fictional nornstone.

Nahadir
2003
Personal work
2362 pixels x 3386 pixels
*Software and platform: Caligari Truespace 6,
Windows XP*

Influenced by a picture of a church, I tried to
capture the sublimeness of the building. The monk
in the foreground carries the 'age-old' – a mystical
pure energy.

Twilight
2003
Personal work
3508 pixels x 4961 pixels
*Software and platform: Caligari Truespace 6.5,
Adobe Photoshop 7, Windows XP*

Created after I'd done a lighting study, this
image shows the starship *Fatum* in a twilight-
like zone of space.

Sharduk
2003
Personal work
4173 pixels x 2362 pixels
*Software and platform: Caligari Truespace 6,
Adobe Photoshop 7, Windows XP*

A moment in the life of a not-too-strange civilization.

TeneT
2003
Personal work
4961 pixels x 3543 pixels
*Software and platform: Caligari Truespace 6,
Adobe Photoshop 7, Windows XP*

A highly developed species has constructed
the TeneT as a means of instantaneous travel
between the stars.

Marcel Barthel (parva)

Marcel Barthel writes: 'I was born in 1981 in Sebnitz, near Dresden, Germany, but have lived in Neustadt since 1982. In 1998, on leaving school, I took further education as a construction designer. My major hobby is art: drawing and 3D computer graphics. I imagine worlds in my mind and capture them through my art. I'd like my pictures to show you these fantasy worlds of my imagination . . .'

www.parva.dusnet.de

MARCEL BARTHEL

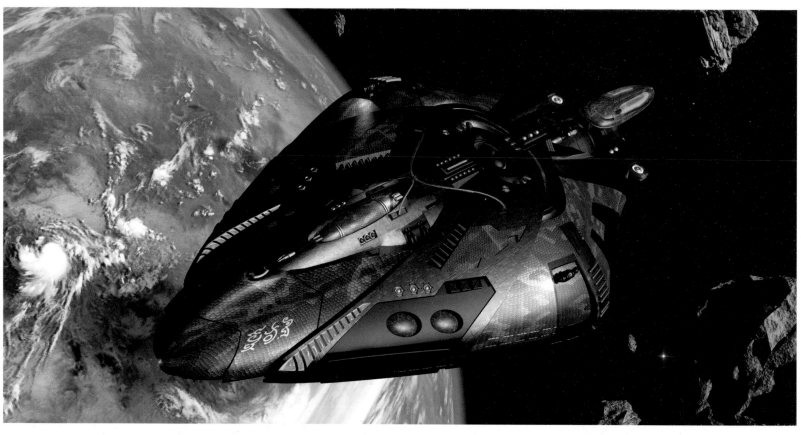

▲ Adamas

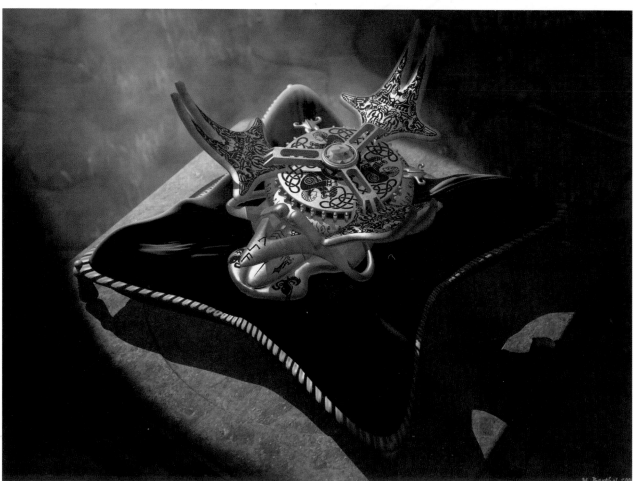

Nornstone ▶

Nahadir ▶

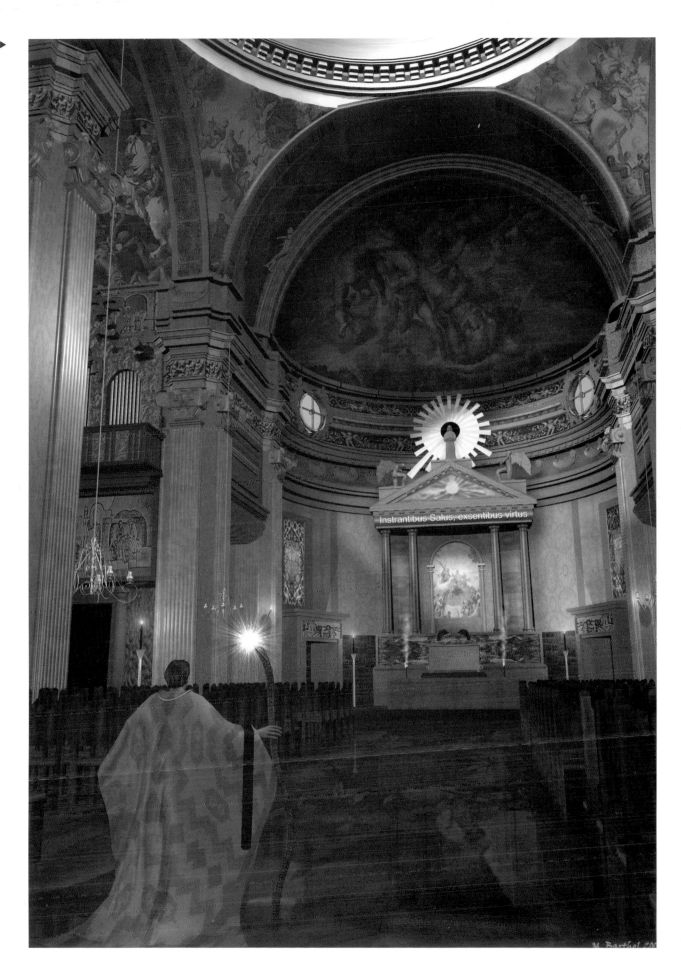

Instrantibus Salus, exsentibus virtus

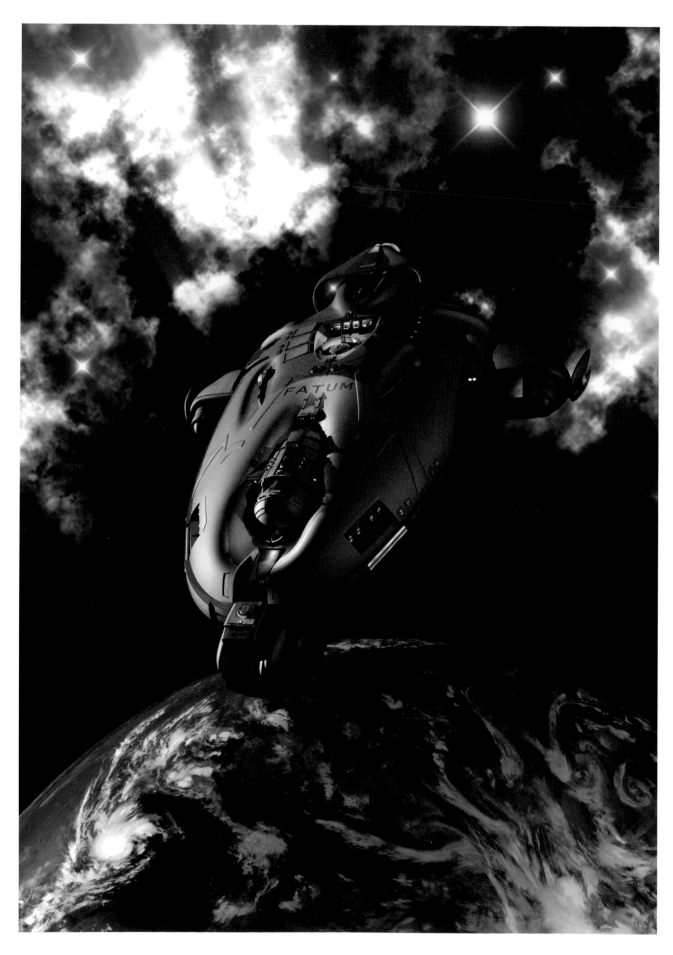

▲ *Sharduk*

TeneT ▶

11

ADAM BENTON

Adam Benton (kromekat)

Adam Benton writes: '"Reality with a twist of improbability" is a precept I like to uphold in many of my images. I have always enjoyed the same kind of principles within the genres of art, film and literature, and from a very early age I was spellbound by science fiction and fantasy in all their forms. As a child, I began to draw things I saw in the movies, TV and comics. Thanks to the encouragement of my parents and peers, my imaginative art grew and flourished.

'As a painter, I started with traditional media; throughout my four years as a student of art and design I focused on acrylics, brush and airbrush. My time at art college helped me refine and channel my skills into becoming an illustrator, although, ironically, very little of that direction came from the colleges or tutors themselves. Instead, I was influenced by the books and portfolios I collected throughout this time by science fiction and fantasy artists, whose work I studied intently.

'I began to explore the possibilities of digital art in 1995 when I bought my first Macintosh. After a couple of years' occasional play with 2D art software packages, I discovered the enormous potential of 3D graphics for creative exploration and the realization of otherwise near-impossible imagery. I found that the true beauty of CG art for me was in its power as a photo-real medium that could be bent, moulded and twisted into the creation of endless illusions and flights of fancy.

'I rarely use traditional media now, but the fundaments of the techniques and principles I learned through many years of drawing and painting serve as an enormous resource when I use my current toolset. I still consider myself a painter, but one who prefers to use polygons, pixels and a screen instead of bristles, pigment and canvas!'

www.kromekat.com

In Safe Hands
2003
Magazine and poster illustration commissioned by a Japanese shipping, port and container company
2551 pixels x 3579 pixels
Software and platform: Cinema 4D, Photoshop, Mac OSX

This is a tightened crop of an image used to illustrate the theme that 'your precious goods are in safe hands'. The advertising agency arrived at the concept of showing a baby held within a grappling claw of the type used by the client, but, as the visual was just a basic 'matchstick' diagram, I had free artistic rein on the claw design.

Jeopardy
2002
Portfolio piece
2400 pixels x 3000 pixels
Software and platform: Poser, Bryce, Photoshop, Mac OS9

A whimsical piece depicting the impending doom of an absentminded fairy – don't ask me why! This image began with the chameleon and my love of the opposition of the sky and skin colours, but the darker side of my imagination demanded a quirk to make it a little different.

Second Empire: Chapter 4 – Day of the Locust: Part III
2001
Personal work
2700 pixels x 1500 pixels
Software and platform: Bryce, Photoshop, Mac OS9

A scene from an ambitious joint project done with friend and fellow-artist Peter Hill to create our own original story set within the *Star Wars* universe thirty years after the events of *Return of the Jedi*. The whole project was inspired by my love of the *Star Wars* saga, and the events that might have unfolded after the original trilogy ended. In this scene a giant docking tower comes under attack from Imperial fighters.

*Second Empire: Chapter 4 – Day of the Locust:
Part V*
2001
Personal work
3200 pixels x 1777 pixels
Software and platform: Bryce, Photoshop, Mac OS9

Another scene from the *Second Empire* graphic
novel. Here the Imperial forces wreak havoc as
they attack the spaceports of the capital planet.
This image involved a combination of imported
models, Bryce-made city buildings, composited
film explosions and Photoshop layer applications.

Sunlight Daydream
2001
Portfolio piece
2370 pixels x 3200 pixels
*Software and platform: Poser, Bryce, Photoshop,
Mac OS9*

As the title suggests, this was inspired by a bright
sunny day and a love of the female form. I set out
to capture a moment of peace, serenity and warmth
with a touch of gentle erotica. One of those 'Don't
move! I have to paint this!' moments.

Terminal
2002
Portfolio piece
2100 pixels x 2900 pixels
*Software and platform: Cinema 4D, Bryce,
Photoshop, Mac OS9*

I like to think of this image as 'retro-futurism'.
I modelled the buildings in Cinema 4D and
recognized a certain retro styling in some of their
shapes, which subsequently inspired the creation
of the sky bus vehicle and the whole colour palette
for the piece. I love the way each era's image of
the future is based on the styling of the present day.

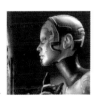

The AI Critic
2002
Portfolio piece, later used as cover image for both
3D World and *New CG* magazines
3500 pixels x 2100 pixels
*Software and platform: Cinema 4D, Poser, Bryce,
Photoshop, Mac OS9*

In this image, I began to explore concepts and sce-
narios that asked questions about artificial intelli-
gence and humanity. I found the idea of an android
being asked to define and judge art an interesting
premise. With her lack of cultural influence, 'taste'
and bias, her judgement would be based entirely
upon programmed 'knowledge' of everything previ-
ously considered as art, yet, as a sentient being
capable of learning emotion and developing an
opinion, what would she feel?

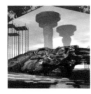

The Abandoned
2001
Portfolio piece
3200 pixels x 1421 pixels
*Software and platform: Cinema 4D, Bryce,
Photoshop, Mac OS9*

A scene inspired by a painting I created in my
teens, which in turn drew its inspiration from the
works of Peter Elson and Fred Gambino. Both
artists influenced me greatly with their visions of
abandoned and derelict alien ships, evoking
many flights of fancy.

The Lovers
2001
Portfolio piece
3225 pixels x 1791 pixels
Software and platform: Bryce, Photoshop, Mac OS9

'Once upon a time, at the edge of an old dark
wood, two lonely trees stood far apart, yet today
they stand together, entwined and joined like lovers.
It's impossible, of course . . . isn't it?' This started
out as a background scene for a character, but I
found the trees compelling enough that they could
actually be the characters.

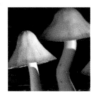

Toadstools
2002
Portfolio piece
3200 pixels x 2464 pixels
*Software and platform: Cinema 4D, Bryce,
Photoshop, Mac OSX*

I needed some fungi for a fairytale illustration
I was working on, and modelled these in Cinema
4D. I was pleased with their realism once textured,
and created this little arrangement in Bryce to show
them off. It works fine as a piece of photorealism,
but I think it's actually waiting for some tiny winged
occupants – of the fae variety!

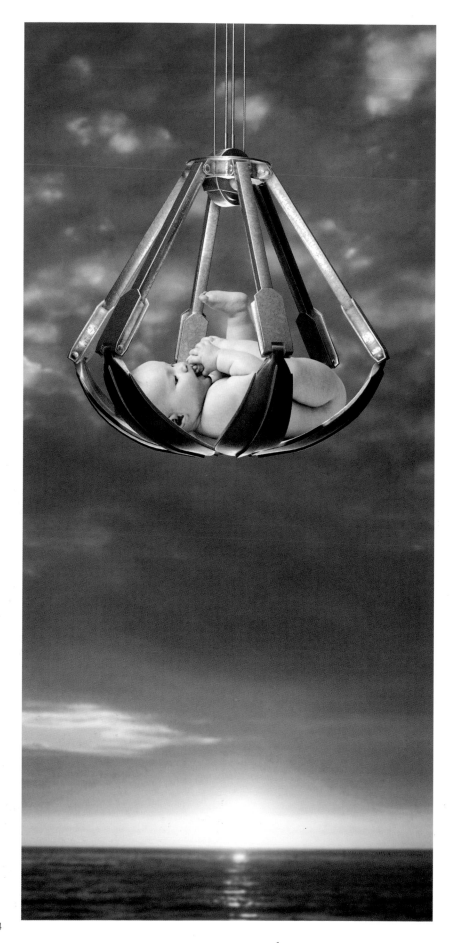

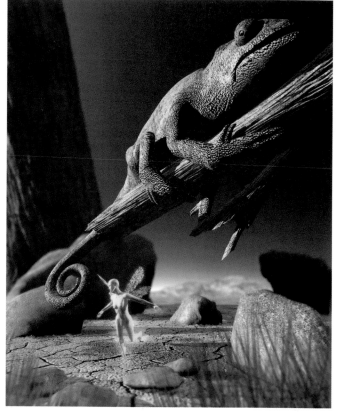

▲ *Jeopardy*

Second Empire: Chapter 4 - ▶
Day of the Locust: Part III

Second Empire: Chapter 4 - ▶
Day of the Locust: Part V

◀ *In Safe hands*

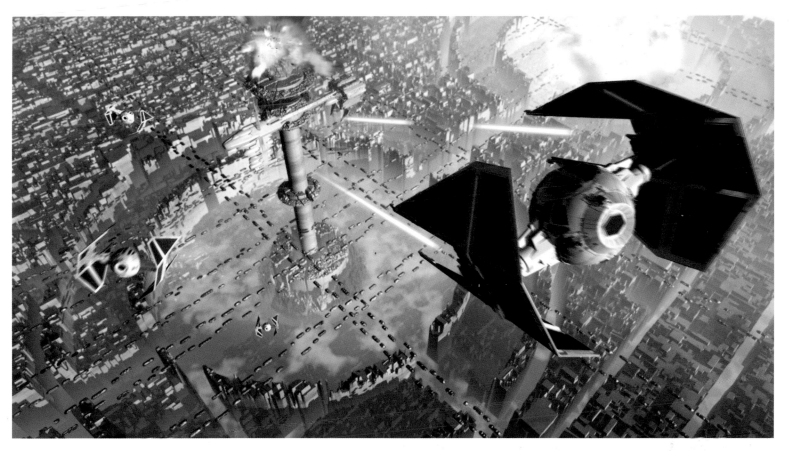

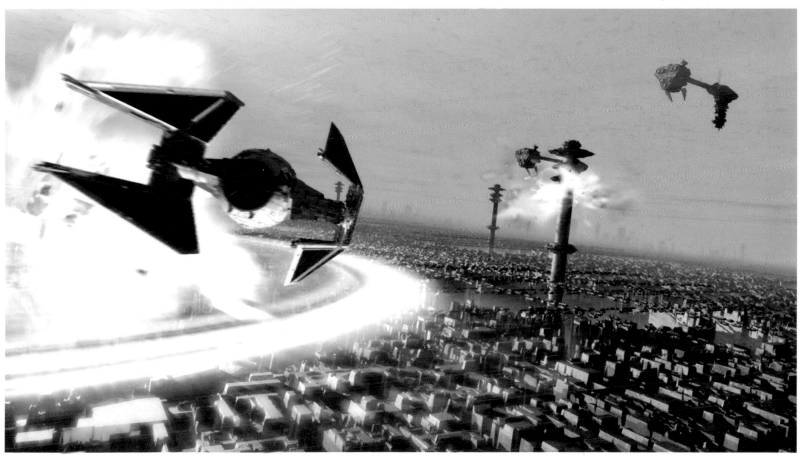

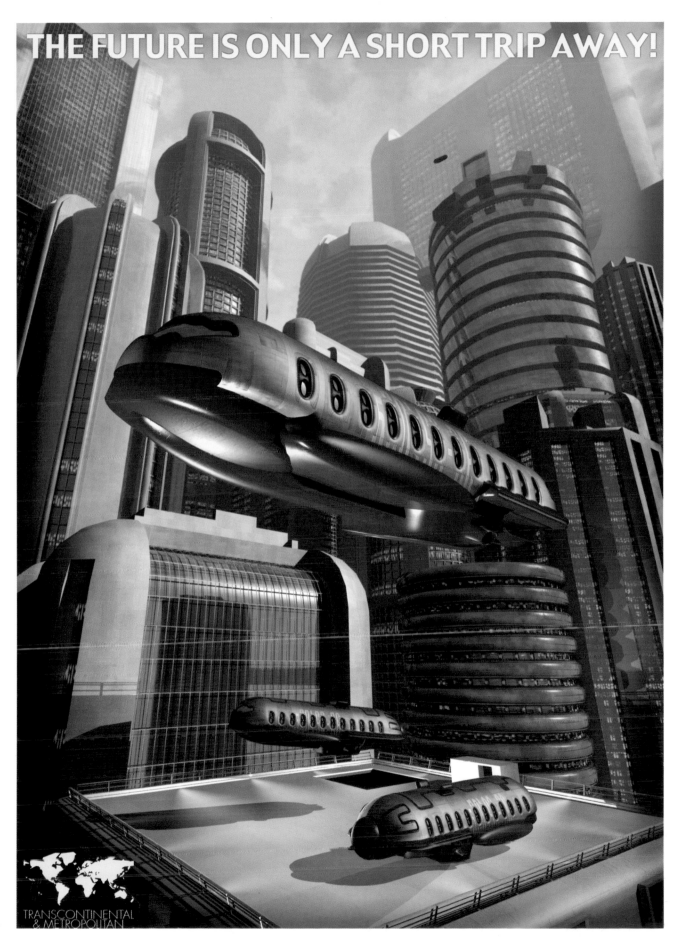

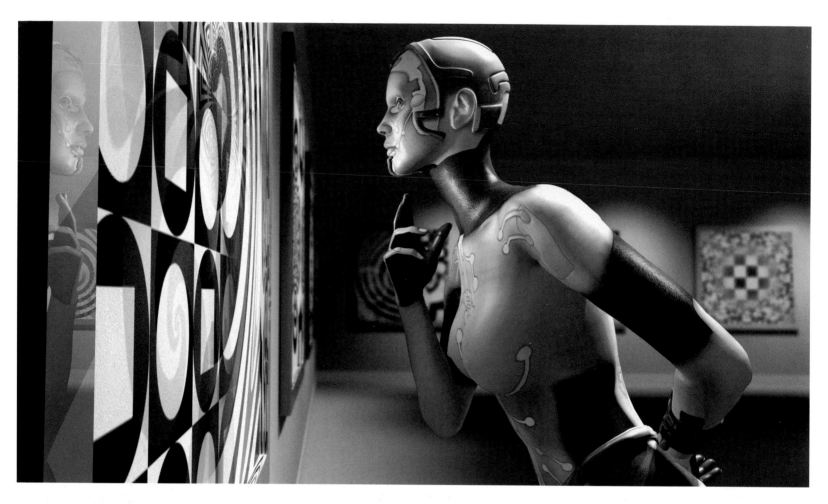

▲ *The AI Critic*

The Abandoned ▼

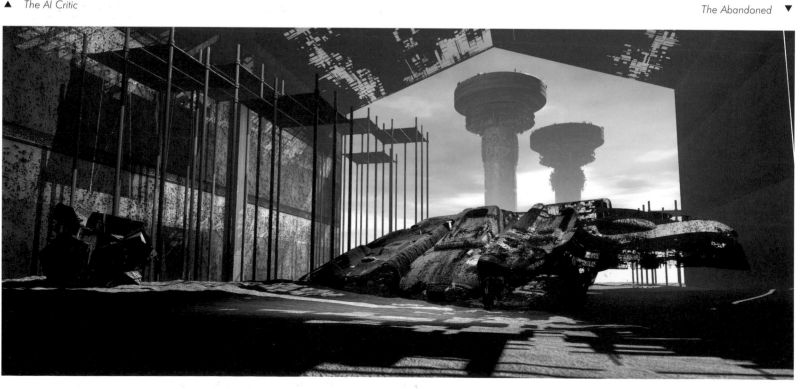

▲ *The Lovers*

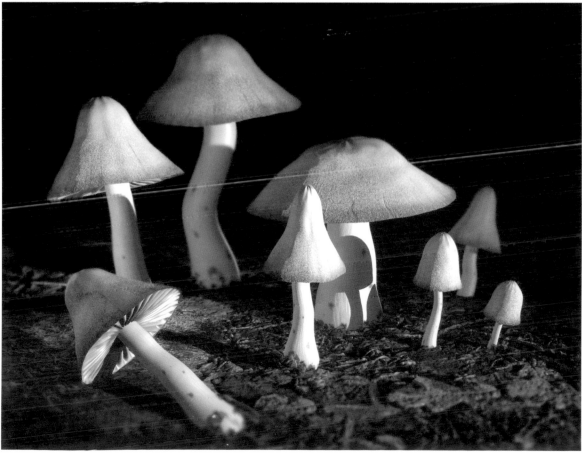

Toadstools ▶

BERNARD DUMAINE

Bernard Dumaine (bern)

Bernard Dumaine was born in 1953 in Angoulême, France, where he lives with his wife Catherine and their children Julien and Lucie. He attained his National Fine Arts Diploma in 1977, and since then has had many solo and group exhibitions, mostly in the region of southwestern France where he lives. He took first price in the M.O.C.A. art contest in March 2003, and his works hang in private collections in France, Great Britain and Germany.

He writes: 'Imagination and chance hold a large place in my pictures, which are also works of experimentation and research. What I love in the process, which is really a kind of stream of consciousness, is the discovery of the picture I am making, because I do not know what will happen until the end. Having drawn "organic" forms over the years, usually without a preparatory model or sketch, I now use a computer and graphics programs to create images which, once they're printed, I sometimes paint traditionally with oils on canvas.'

www.e-mages.fr.fm
www.renderosity.com/homepage.ez?Who=bern

Magical Mystery Tool
2001
Trompe-l'oeil piece
2550 pixels x 2984 pixels
Software and platform: Adobe Photoshop, Windows XP

This picture was developed from an ink sketch I did in 1995. I did a large oil painting of it using a print of my digital image as a template.

Coz
2002
Personal work
1100 pixels x 1400 pixels
Software and platform: Adobe Photoshop, Windows XP

This was the first picture in my Coz series.

Coz 13
2002
Personal work
2550 pixels x 2983 pixels
Software and platform: Adobe Photoshop, Windows XP

Another title I use for this picture is *Sin Titulo*.

Forme
2002
Personal work
2550 pixels x 2984 pixels
Software and platform: Adobe Photoshop,
Windows XP

This is an experiment in black-and-white to
concentrate my work on forms instead of colours.

Sweet Dreams
2003
Personal work
1200 pixels x 930 pixels
Software and platform: Adobe Photoshop,
Windows XP

The last of my 'blue' series.

Season of the Witch
2002
Personal work
1116 pixels x 1474 pixels
Software and platform: Adobe Photoshop,
Windows XP

The title is from a Donovan song.

Untitled
2003
Personal work
1454 pixels x 1099 pixels
Software and platform: Adobe Photoshop,
Windows XP

Step 9
2003
Personal work
1200 pixels x 930 pixels
Software and platform: Adobe Photoshop,
Windows XP

War
2003
Personal work
1454 pixels x 1099 pixels
Software and platform: Adobe Photoshop,
Windows XP

The title *War* is the original one, but I sometimes
call this image *Coz 14.*

Step 3
2003
Personal work
1693 pixels x 2031 pixels
Software and platform: Adobe Photoshop,
Windows XP

▲ *Magical Mystery Tool*

▲ Coz 13

Forme ▶

◀ *Coz*

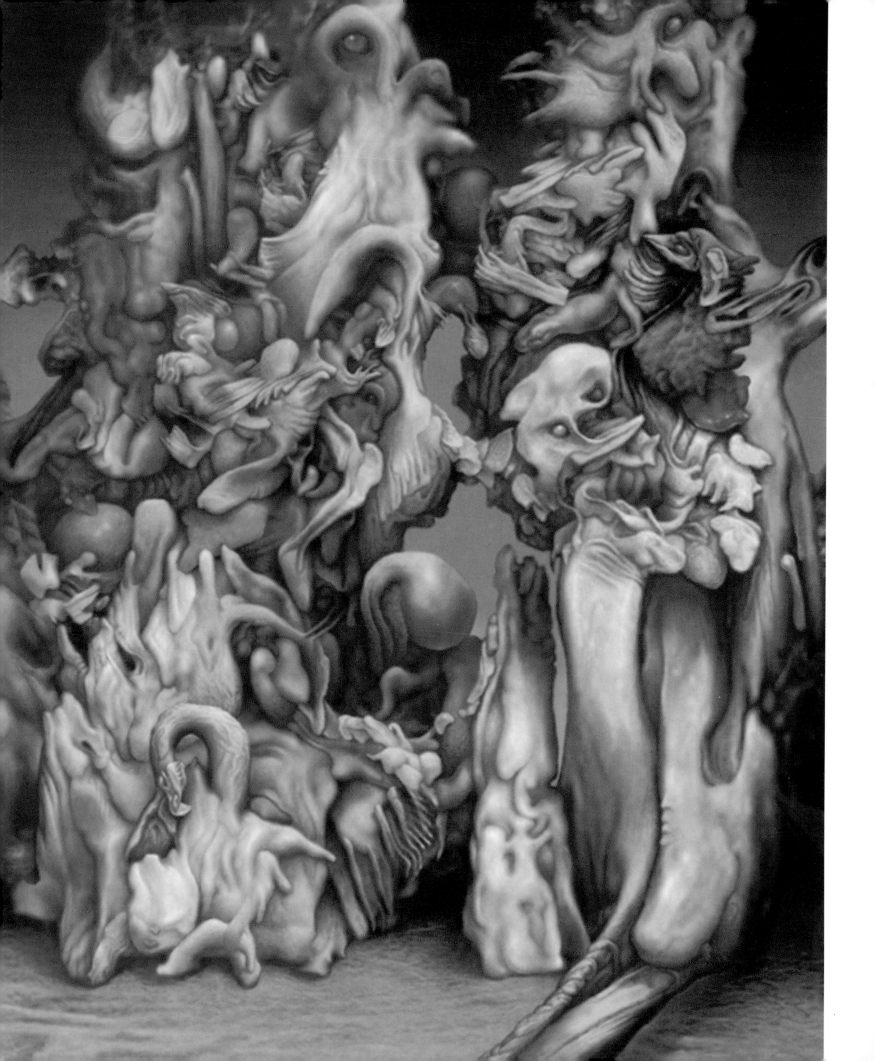

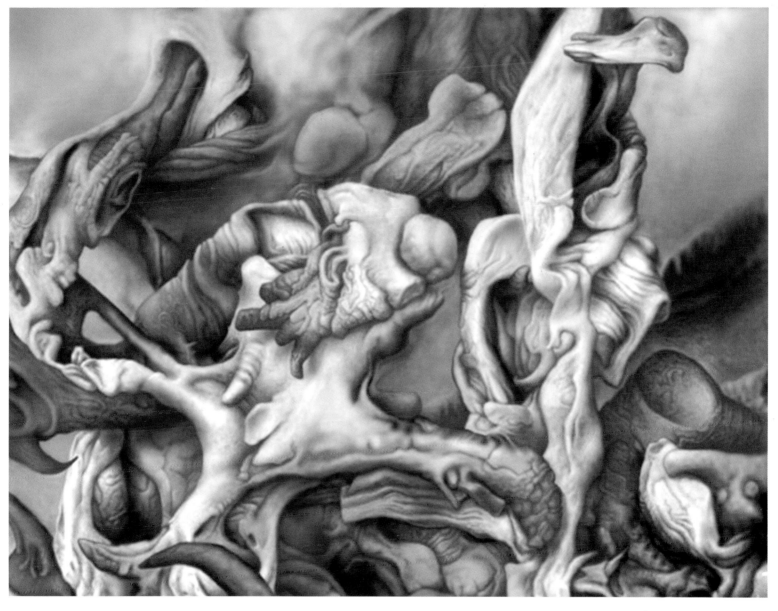

▲ Step 9

Step 3 ▶

◀ Season of the Witch

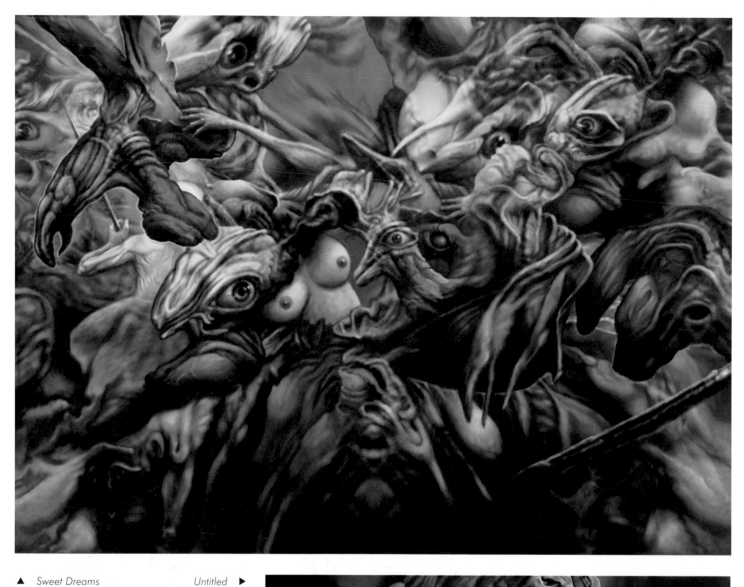

▲ *Sweet Dreams* *Untitled* ▶

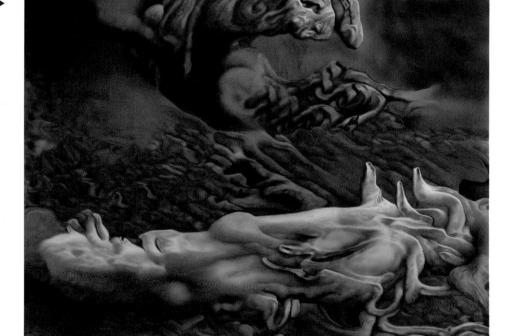

War ▶

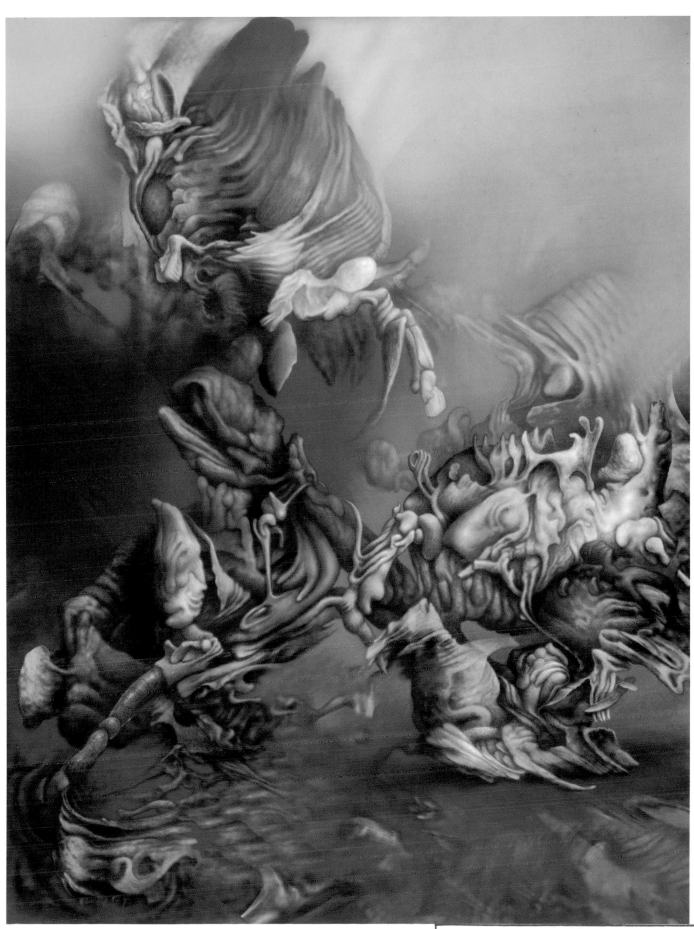

MATT HANSEL

Matt Hansel (stealthman)

Matt Hansel writes: 'It was in college in 1989 that I first started generating computer art. Many in the art department thought computers could aid in the graphic design process but had very little else to offer the artist. When I tried to declare Computer Art as a minor, I was told that it wasn't *real* art – and the art department just couldn't help me. My instructor had the last laugh, it would seem: he ended up moving all of his equipment to the Mass Communications department, and each year the art students crowd into his courses, which give them the Computer Art experience they crave.

'Since college I've been working steadily in the video-game industry for both PC and console games. For the first eight years I was content just to make games. For the last several years, however, I've found I really enjoy practising my artistic skills outside work as well. It's the only way I know to meet challenges you don't get on the job day to day.

'My influences have always leaned towards more unconventional art. Lately I've really been into Todd Schorr, Robert Williams, Mark Ryden and – from an earlier period of art history – Salvador Dalí.

'As for my own work, I believe the most successful pieces I do not only show beauty in details but evoke a sense of mystery and wonder. There is nothing I enjoy more than discovering and then showing to other people a hidden world they don't normally see.'

www.renderosity.com/homepage.ez?Who=stealthman

Tormentia
2003
Personal work
1200 pixels x 1200 pixels
Software and platform: Poser, Photoshop, Windows XP

My fiancée, Julianne Soffe, is a horrible torment! When the mood hits her, she loves to keep me on my toes by picking away at me. This image was inspired by that, and by a want to create another piece using the techniques I had begun to explore in my other work.

All Built the Same
2002
Personal work
1500 pixels x 1125 pixels
Software and platform: Maya, Poser, Photoshop, Windows XP

I wanted to create a family of characters made up of the same components – and show them slowly coming to the realization (at whatever plane of consciousness they might be on) that they are all made up of the same mechanical parts.

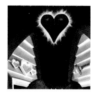

Adam & Eve
2003
Personal work
832 pixels x 1000 pixels
Software and platform: Maya, Poser, Photoshop, Windows XP

This was an experiment with the new renderer for Maya, Mental Ray. I had been struggling with Maya's renderer for years, and was happy to see this plug-in surface so the lights would work the way I expected them to. It was a fun modelling job – and my first real dive into more earthy elements.

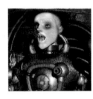

Circus
2003
Personal work
1000 pixels x 599 pixels
Software and platform: Maya, Photoshop, Windows XP

I was trying to imagine one of those carnivals that set up in your town one week and are gone the next – and, more specifically, the ghost rides. In retrospect, I probably wouldn't want to go on this ride.

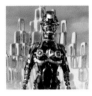

Android 1002
2002
Personal work
600 pixels x 1000 pixels
Software and platform: Bryce, Maya, Poser, Photoshop, Windows XP

Soon to be sold in stores everywhere! Or at least on some distant planet . . . This started as a modelling challenge and then somehow became an action figure. I was fascinated by the endlessness of the reflections in the metal rings, and wanted to explore a different colour scheme than the one I tend to lean towards.

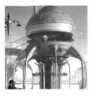

Basis for Orcon 3
2002
Personal work
1000 pixels x 750 pixels
Software and platform: Maya, Bryce, Photoshop, Windows XP

Having worked on sci-fi games, I had always wanted to create a fictional image with incredible scale to it. I don't think I'll ever feel that this piece is as 'complete' as I'd like it to be, but it has satisfied me enough that I've been able to move on to other things. Maybe someday I'll revisit this . . .

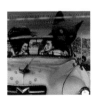

Milkbone Prrrfect
2002
Personal work
1600 pixels x 1200 pixels
Software and platform: Poser, Photoshop, Mavica 2.1megapixels, Windows XP

I took some photographs in an amazing car showroom display. I wanted to create an image using some of the shots, and originally intended to have a car full of dogs chasing a car full of cats, à la Gary Larson. While toying with the poses of the cats I found a pose so ridiculously fake that it made me laugh. I then felt it would be funnier if the dogs only believed they were chasing real cats.

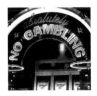

In Vegas
2002
Personal work
900 pixels x 1000 pixels
Software and platform: Maya, Photoshop, Windows XP

In Vegas stemmed from the idea that these days the city of Las Vegas is always trying to convince people that it's all about just having fun – that the last thing on their minds is worrying about how much you gamble. They counter the message by throwing so much gambling in your face and stuffing it down your throat on billboards and matchbooks and in grocery stores that it all seems . . . well, a bit contradictory.

Recharging
2002
Personal work
1000 pixels x 750 pixels
Software and platform: Maya, Illusion, Photoshop, Windows XP

I wanted to create a mechanical abstract in the form of a ship – a science fiction abstract. This image was also the result of a technique of organic polygonal modelling I was toying with in Maya.

Stairway
1994
Personal work
800 pixels x 600 pixels
Software and platform: 3d Studio (later Max), Windows 3.1

This image was my first attempt at 3D, and I learned a lot in making it. The architectural structure was the focus, although the time of day and the mood set by it ended up playing a larger role.

MATT HANSEL

Adam & Eve ▶

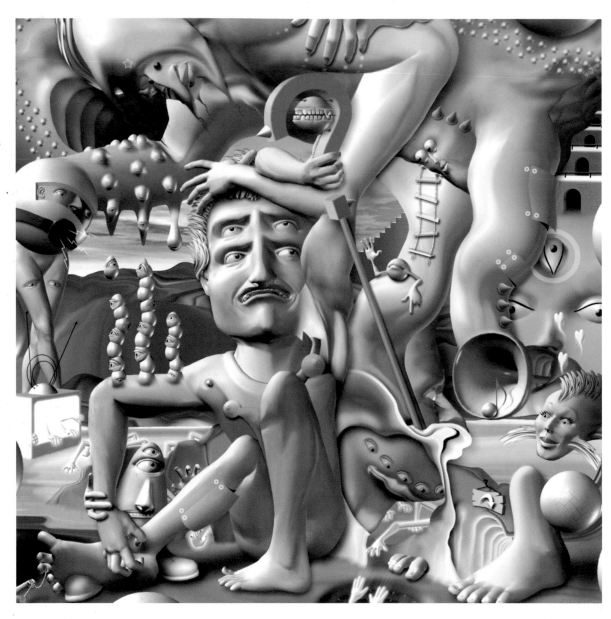

▲ *Tormentia*

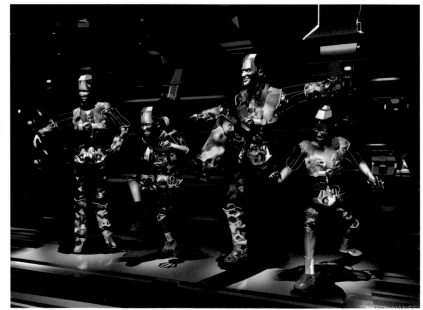

All Built the Same ▶

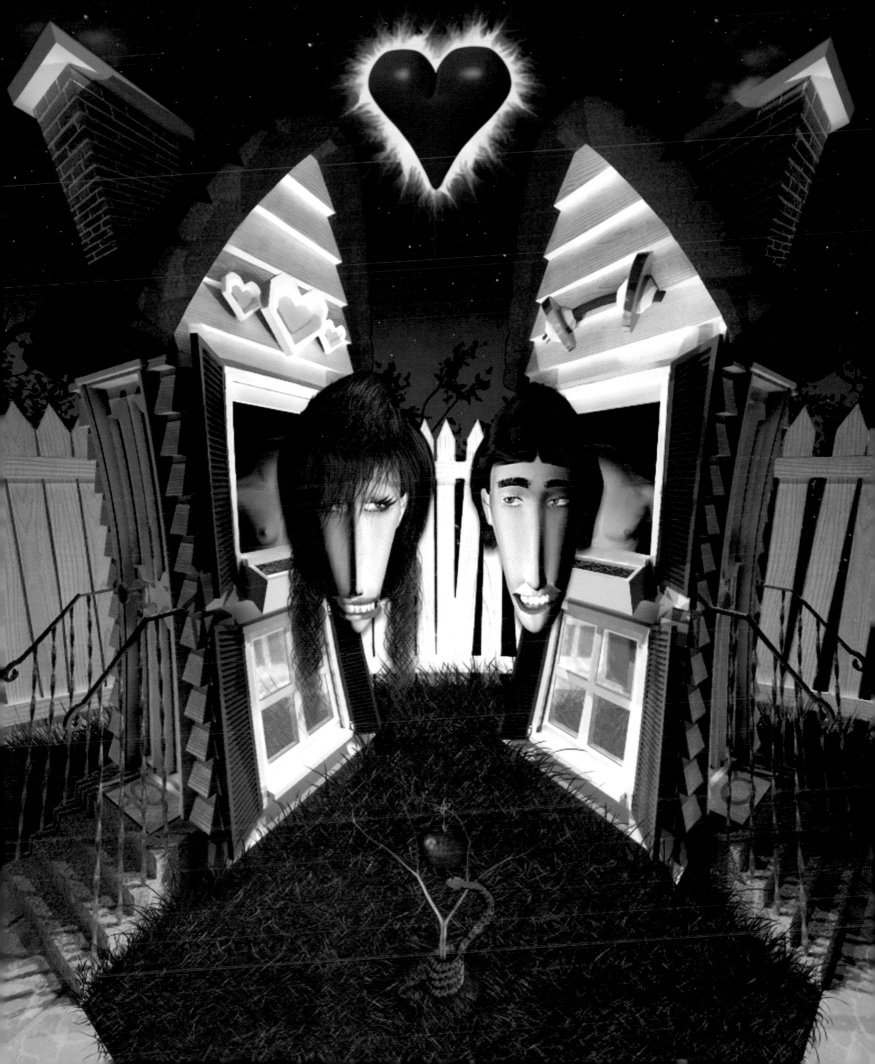

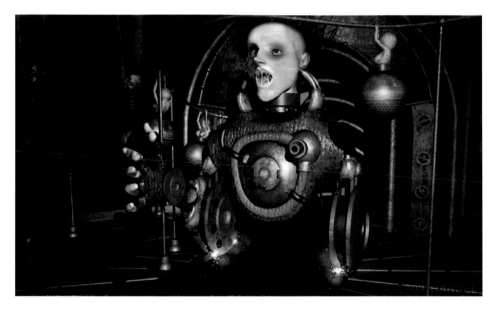

▲ *Circus*

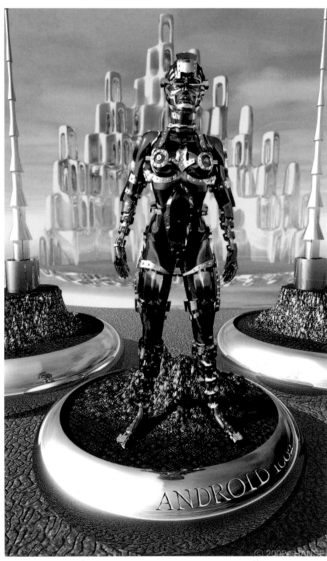

Android 1002 ▶

Basis for Orcon 3 ▶

Milkbone Prrrfect ▶

▼ *In Vegas*

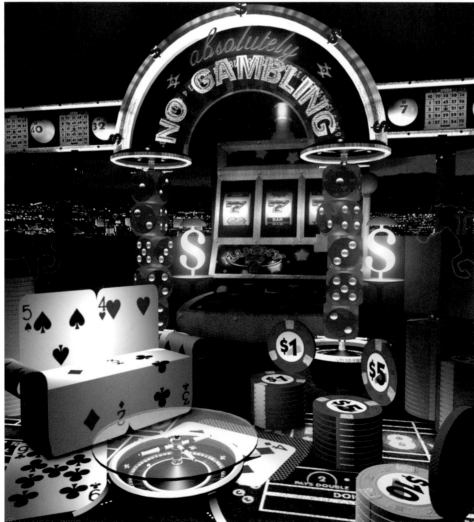

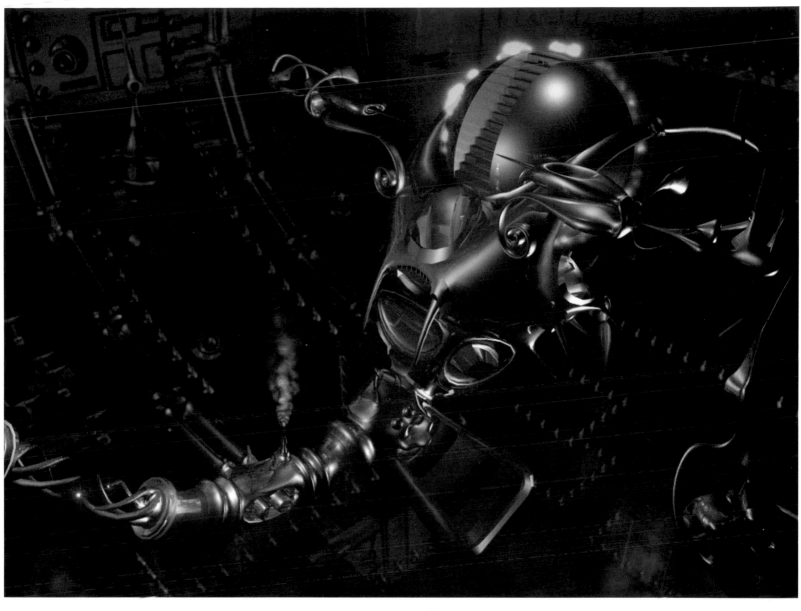

▲ *Recharging*

◄ *Stairway*

DAVID HO

David Ho

David Ho was born a Virgo under the Chinese horoscope of the Rooster. He has been an artist for the past fifteen years and a digital artist for the past ten. Many people have asked him why he creates such dark imagery, and his response is that it's his way of unleashing and expressing his demons. He writes: 'Tortured by my own mental demons, I enter another dimension, a dimension where all of my angers, fears, desires and frustrations are expressed freely, without inhibition. Though this world is of the fantastic, many of the themes I explore are based on my observations of the realities of life. In my world of art I am god, passion is my disciple, and repression is my antichrist. I become a master of my own creations, a power, an energy, where my subjects become a muse – puppets for me to manipulate and exploit, allowing the viewer to empathize. To me, art is self-therapy. Through it, I manage to channel my negative energy, creating a world magically dark yet – I hope – delightfully intriguing.'

www.davidho.com

(C12) *Fear of Truth*
2001
Personal work
3000 pixels x 3000 pixels
Software and platform: Poser, Photoshop, Bryce, Illustrator

Part of my *Contemplation* series.

Centaur and Soul
2000
Personal work
2550 pixels x 3300 pixels
Software and platform: Poser, Photoshop, Bryce, Illustrator

Part of my *Dante's Inferno* series.

(Canto3) *Ship of Fools*
2000
Personal work
2550 pixels x 3300 pixels
Software and platform: Poser, Photoshop, Bryce, Illustrator

Part of my *Dante's Inferno* series.

(C24) Something to Believe In
2000
Personal work
3300 pixels x 3300 pixels
*Software and platform: Poser, Photoshop, Bryce,
Illustrator*

Part of my *Contemplation* series.

Nature vs. Nurture
2000
Personal work
2550 pixels x 3300 pixels
Software and platform: Poser, Photoshop, Bryce

Part of my *Contemplation* series.

Leviathan
1999
Personal work
3150 pixels x 3150 pixels
Software and platform: Poser, Photoshop, Bryce

Part of my *Contemplation* series.

Man Created God
2003
Personal work
3300 pixels x 3300 pixels
Software and platform: Poser, Photoshop, Bryce

Part of my *Block* series.

Fear of Perfection
2001
Personal work
3000 pixels x 3000 pixels
*Software and platform: Poser, Photoshop, Bryce,
Illustrator*

Part of my *Contemplation* series.

The Dreamer
2003
Personal work
2550 pixels x 3300 pixels
*Software and platform: Poser, Photoshop, Bryce,
Illustrator*

Part of my *Contemplation* series.

The Cloudmaker
2003
Personal work
3300 pixels x 3300 pixels
Software and platform: Poser, Photoshop, Bryce

Part of my *Contemplation* series.

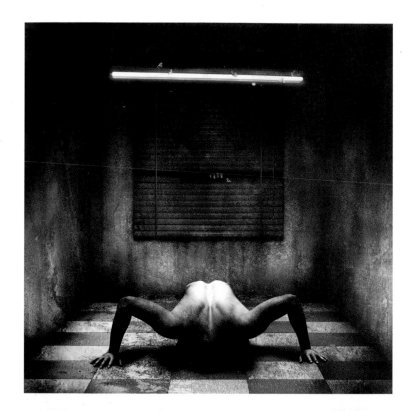

◀ (C12) Fear of Truth

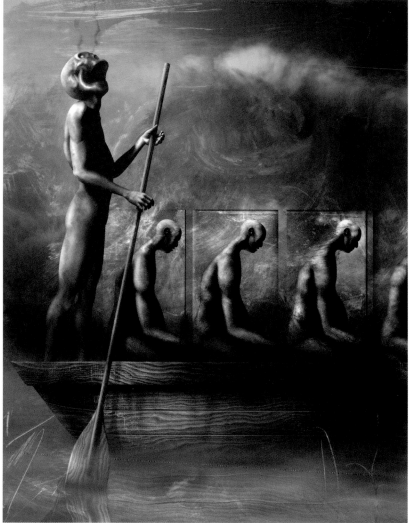

▲ (Canto3) Ship of Fools

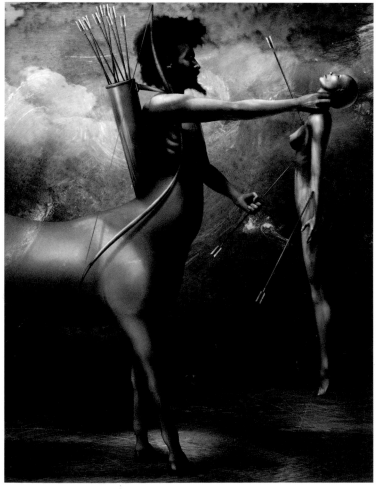

◀ Centaur and Soul

(C24) Something to Believe In ▲

▲ *Leviathan*

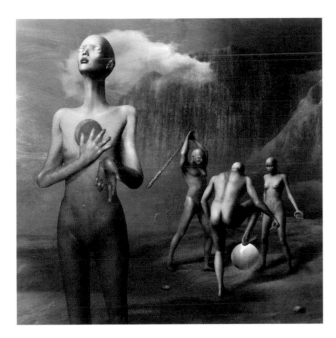

▲ *Fear of Perfection*

▼ *The Cloudmaker*

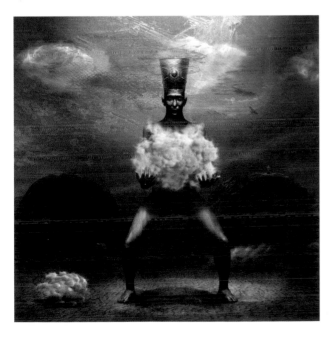

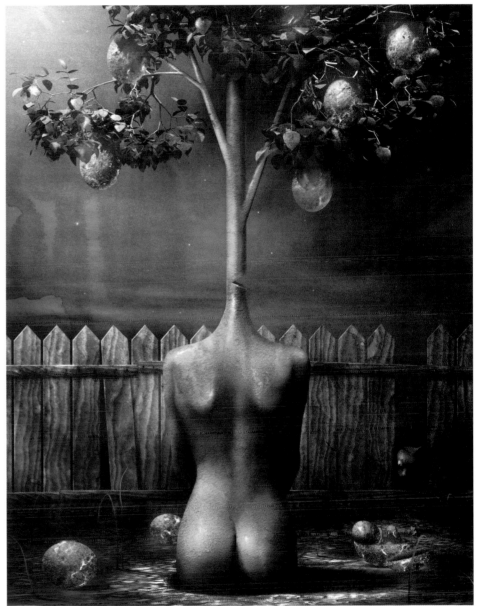

Nature vs Nurture ▲

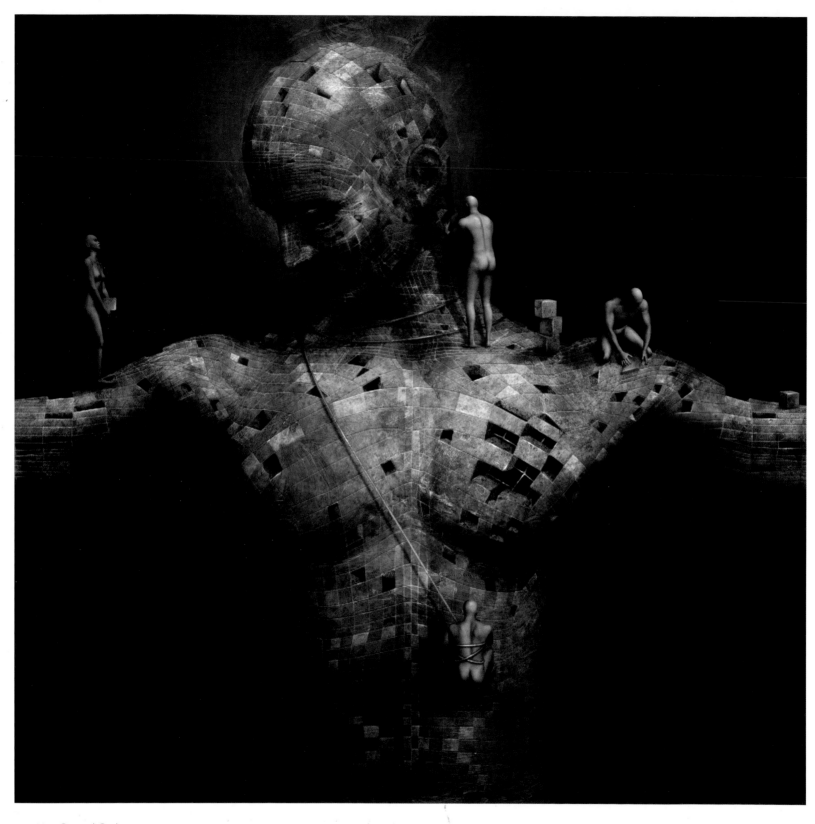

▲ Man Created God

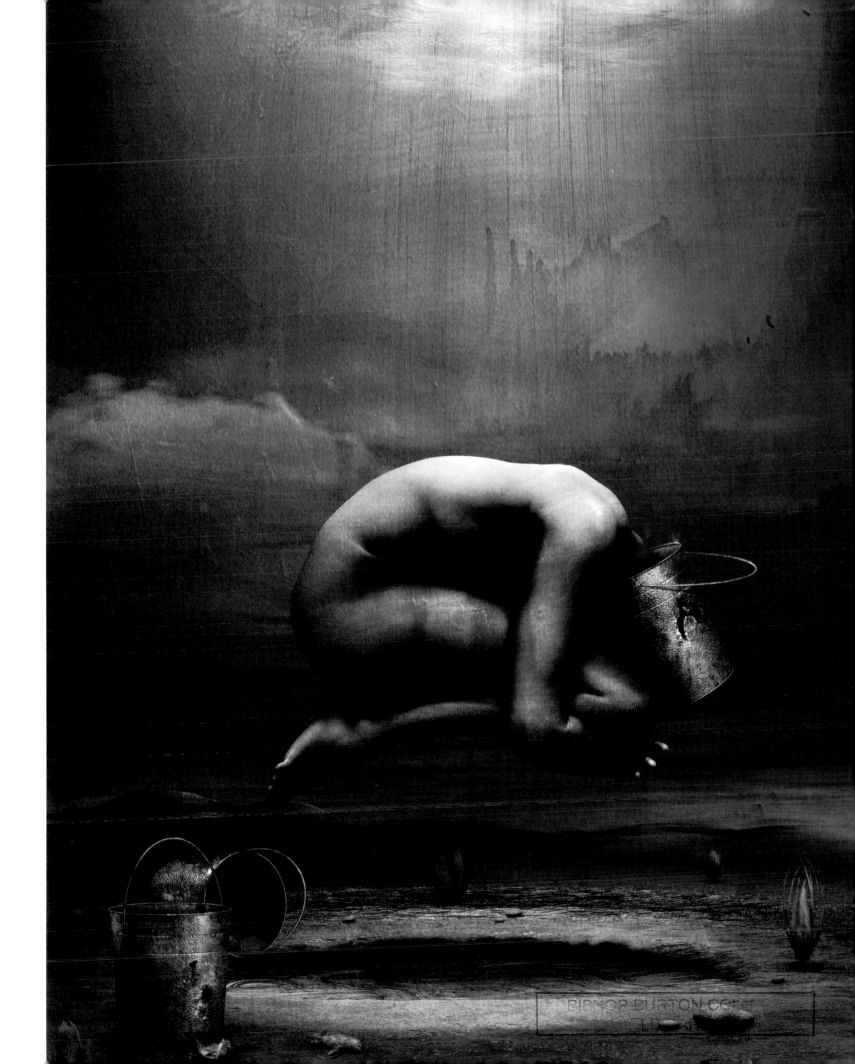

MICHAEL KOMARCK

Michael Komarck

Michael Komarck writes: 'As I sat doodling in high school geometry classes it became apparent to me that what I wanted was a career in art. True, my grades were slipping as a result of my love for drawing, but wasn't this an acceptable sacrifice in the pursuit of something loftier? And who was this Pythagoras guy, anyway? In retrospect, I might have benefited from paying more respect to Pythagoras, but here I am, doodling for a living.

'I always had a soft spot for things to do with science fiction and fantasy. I would buy books because the cover art captivated me, and never read a word inside. I wanted to create those images, those worlds. So, fifteen years later, I found myself wondering how I'd got stuck doing design work for corporate brochures and illustrations for self-help books. I had to get back on track. The answer was right in front of me all along.

'I was fluent in Adobe Photoshop, but had never dreamed of using it to "paint" with. I painted in oils, and there was no way I would compromise my artistic integrity by trading in my brushes and paints for a soulless machine. Still, I began noticing the digital work of other artists, work I sometimes didn't initially realize was digital, and I decided it wouldn't hurt to test the waters. I was hooked. Gradually my work became more and more digital as I began dabbling with various 3D programs to create references for my paintings. My productivity increased dramatically, and I was able to produce a portfolio that got the attention of the Art Director of Meisha Merlin Publishing. I've since created covers for such authors as George R.R. Martin, Robert Asprin, Jody Lynn Nye and Phyllis Eisenstein. I'm currently working on a cover for one of the *Dragonlance* series published by Wizards of the Coast.'

mkomarck@comcast.net
www.komarckart.com

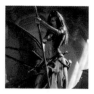

Bloodied Mary
2003
Portfolio piece
7658 pixels x 9600 pixels
Software and platform: Adobe Photoshop, Windows XP

I set out originally to have the figure completely soaked in the blood of her vanquished foe. Apart from this being unnecessarily gruesome, I found it obscured too many details, so I toned down the gore.

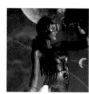

Astrogirl
2002
Portfolio piece
1942 pixels x 4408 pixels
Software and platform: Adobe Photoshop, Windows XP

While rummaging through the attic, I came upon a stack of my father's old magazines from the 1960s, particularly *Famous Monsters of Filmland*. I wanted to create an image that captured that great retro look of the old black-and-white sci-fi films and serials.

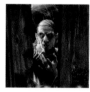

Skeeve's Illusion
2003
Interior illustration for *M.Y.T.H. Alliances* by Robert Asprin and Jody Lynn Nye (Meisha Merlin)
3000 pixels x 4483 pixels
Software and platform: Adobe Photoshop, Windows XP

One of six interior illustrations for the book *M.Y.T.H. Alliances*. In this scene, the magician Skeeve alters his appearance as he answers his door, to drive off unwanted guests. The dog is his pet dragon Gleep, also under the illusion spell.

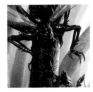

Climber
2002
Portfolio piece
3333 pixels x 6000 pixels
Software and platform: Adobe Photoshop,
Windows XP

I remember very little about what originally inspired
this image, probably because I wasn't pleased with
it at the time. Often my colour palette consists of very
muted tones, but this one struck me as being almost
devoid of all colour – far too grey. I went back and,
in one sitting, reworked the image as you see it.

The Book of Elementals
2003
Cover illustration for *The Book of Elementals:*
The Saga of the Sorcerer's Son Volumes One and
Two by Phyllis Eisenstein (Meisha Merlin)
6000 pixels x 9000 pixels
Software and platform: Adobe Photoshop,
Windows XP

A special piece for me, as it was my first
commissioned fantasy book cover. I'm currently
working on the cover for the next two volumes,
also to be published by Meisha Merlin.

Viridis
2002
Portfolio piece
3825 pixels x 7440 pixels
Software and platform: Adobe Photoshop,
Windows XP

This image began as an oil painting done several
years earlier. I revisited the painting from time to
time, revising it here and there, but was never
completely happy with the results. After making
the transition to digital techniques, I scanned in
the image and reworked it entirely that way.
I'm much happier with it now.

Portal
2002
Portfolio piece
6000 pixels x 4614 pixels
Software and platform: Adobe Photoshop,
Windows XP

This was my first attempt at an image rooted
simultaneously in the realms of science fiction
and fantasy.

Mech
2003
Portfolio piece
8477 pixels x 9600 pixels
Software and platform: Adobe Photoshop,
Windows XP

After completing several fantasy-based images, I
decided to return to science fiction, and created
this piece. My original intention was to have dozens
of mechs attacking the city. Maybe someday I'll go
back and 'finish' the image that way.

Treetops
2002
Portfolio piece
9600 pixels x 5400 pixels
Software and platform: Adobe Photoshop,
Windows XP

I've always been fascinated by the quality of light
at sunset. While driving home one evening I was
particularly struck by the deep orange hues, which
I tried to commit to memory. On reaching home I
immediately knocked out a rough sketch, from
which this image was born.

Astrogirl ▶

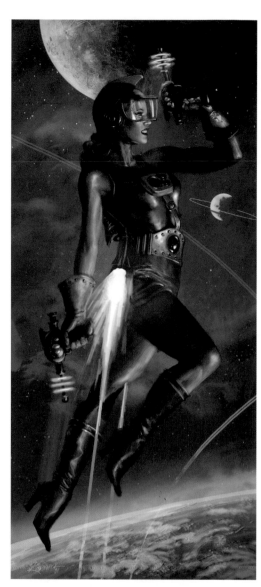

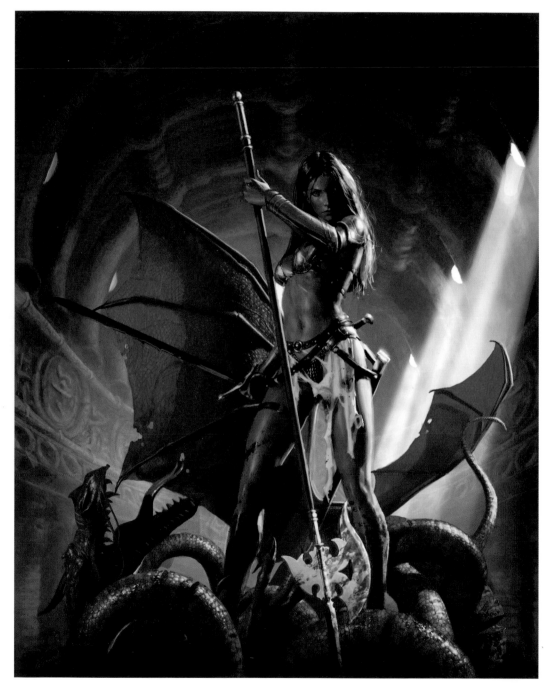

▲ Bloodied Mary

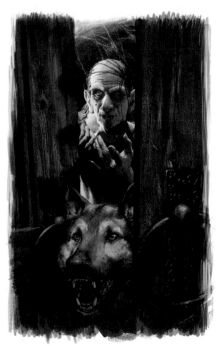

Skeeve's Illusion ▶

◄ Climber

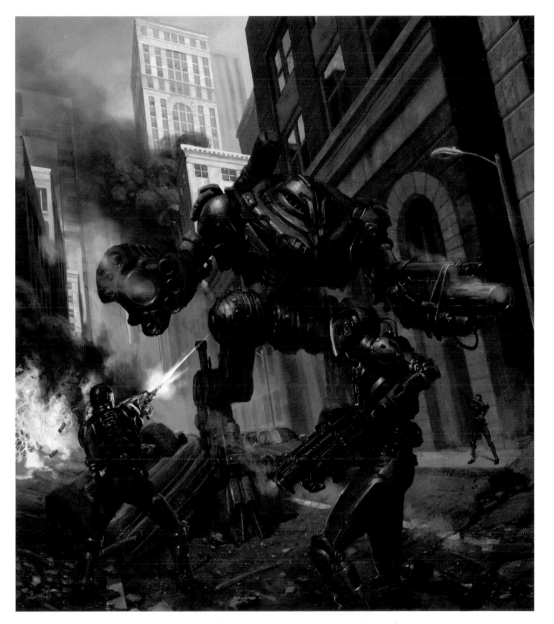

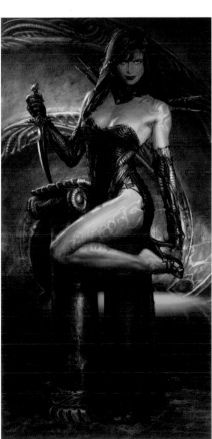

Mech ▲

◄ Viridis

▲ *Portal* *Treetops* ▶

◀ *The Book of Elementals*

VOD LAND

Vod Land (vod)

Vod Land writes: 'I was about four or five when I did my first comic strip, with a ballpoint pen. My first success in drawing came in nursery school: unsatisfied by my depiction of the lava flowing from a volcano (coloured lines in all directions), I covered it with smoke using a large felt-tipped pen. The teacher took the drawing and showed it to the class as an example not to be followed: a sheet of paper almost completely black.

'My parents taught me a feeling for art from an early age. Without understanding much, I was nonetheless astonished to see some quite zany things in art – surely culture was supposed to be a very serious matter? In my early teens I wanted above all to work as an artist – to draw comics professionally, to create trompe-l'oeil paintings, or to paint in the style of NASA pictures – but it didn't work out. In the painting exam for the *baccalauréat* I allowed myself to ramble in all directions, which got me an average-to-good mark, no more.

'Later, when I was about 18-19 years old, I used Rotring pens, trying to teach myself to forget the rules and tame my old drawing habits. A long while after that, the coming of computers was a revelation, especially for colour working. But one never forgets one's roots.

'My thanks to all from the past and the present who have helped and influenced me. Double thanks to Phil for helping me with this translation.'

www.vodland.free.fr
www.renderosity.com/homepage.ez?Who=vod

Alzheimer
2002
Personal work
8in x 11in (20cm x 28cm) (original)
Software and platform: Paper, Photoshop (Mac)

The big character was an experiment in a luminescent texture. I wanted to convey the idea that people with Alzheimer's disease are halfway between our world and the next.

Ergo Sum
2002
Personal work
2360 pixels x 3300 pixels
Software and platform: Photoshop (Mac)

Done more for the pleasure of working on digital matter than with the intention of creating a finished product. This was done during a time of self-doubt about my work, of lack of inspiration. Really, I've never quite accepted this picture, yet it belongs to me . . .

Speedy Cat
2002
Personal work
2360 pixels x 3300 pixels
*Software and platform: Photoshop,
a little Poser/Amorphium (Mac)*

The texture of this image was derived in part from embedding a layer of a scanned old sponge. I sometimes use this technique on other images.

El Guignolo
2002
Personal work
8in x 11in (20cm x 28cm) (original)
Software and platform: Paper, Photoshop (Mac)

Punishment and reward. It is quite remarkable
that in the 21st century we still function like
laboratory mice . . .

Problem Child
2003
Personal work
2360 pixels x 3300 pixels
*Software and platform: Photoshop,
a little Poser/Amorphium (Mac)*

A wink to those who already have lots, and who
want even more. To those who have big ideas and
want everybody else to think the exact same way:
it can be ourselves, some companies, the media,
countries and of course a lot of religions –
potentially everyone. The 'problem child' is a
nasty kid, stubborn and impatient.

Moreau Institute
2002
Personal work
2360 pixels x 3300 pixels
*Software and platform: Photoshop,
a little Poser/Amorphium (Mac)*

As often in my '100% digital' work, I experimented
by bringing forth random shapes on the computer
and making a picture from them afterwards.
A lot of my bases are made in 72dpi; this allows
me to get interesting effects with some filters, and
particularly textures.

Retrolidays
2002
Personal work
2360 pixels x 2360 pixels
*Software and platform: Photoshop,
a little Poser/Amorphium (Mac)*

Based on some kind of beach picture. The girl
and the cloth on which she leans gave me some
difficulties. I had to redo an arm only a few minutes
after publication on renderosity.com. It happens very
often that, just after web publication, I see obvious
mistakes and — too late! — click on 'delete'. Maybe
because the umbilical cord must be cut, the work,
now public, gains its own life, so the view of the
person who created it becomes irrelevant.

Mystery Brain
2002
Personal work
2360 pixels x 3300 pixels
Software and platform: Photoshop (Mac)

It was I think the title, which refers to a film by
Jim Jarmusch, that inspired this picture. This crazy
pilot, burdened by a conscience, is sometimes
problematic for me. I almost see a Nazi swastika
in the composition, which was not intended.

The End of 2002
2003
Personal work
2460 pixels x 3300 pixels
Software and platform: Photoshop (Mac)

An 'energetic' attempt after a period of lethargy, a
year which was, shall we say, politically perilous – in
France with the presidential elections, worldwide with
the consequences of 9/11. This repressive climate
brought me to ask myself a lot of questions on the
purpose of art (and the artist) in society.

That is the Question
1996
Illustration for art newspaper
11in x 15.75in (28cm x 40cm) (original)
Software and platform: ink and paper

When I do this kind of picture in black-and-white, I
try to couple free-form (a very quick sketch) with a
structure of some kind – often a simple horizon line.
Sky and ground, a scene where the characters may
be placed. Here it is part of a sphere. The dotted
line manages, without too much fuss, to give a
finished aspect to the whole.

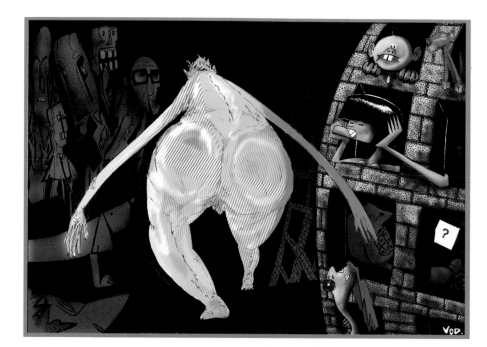

◄ *Alzheimer*

▼ *Speedy Cat*

▲ *El Guignol*

◄ *Ergo Sum*

Moreau Institute ▶

▲ Mystery Brain

◄
That is the
Question

Problem Child ▶

◄ *Retrolidays*

▼ *The End of 2002*

JAMES LEE

James Lee (jjmslee)

James Lee writes: 'I am a self-taught 3D graphics artist living in Brighton, Michigan. Although I am an operations manager by day, I devote most of my free time in the evenings and weekends to creating images. It may be evident from my illustrations that my inspiration comes from great science fiction movies like *Star Wars* and *Blade Runner*. I particularly enjoy creating photo-realistic images with a retro sci-fi look depicting unusual characters, props and situations. I also try to incorporate many details into my work, which are intended to encourage the viewer to really *look* at the illustrations. I typically use Rhinoceros, Bryce 5 and Poser 5 to model and render, and PhotoPaint 10 for post-production and texture.

'My current body of work focuses on an accidental heroine, a mouse named Claude and an ensemble of alien characters whose paths intersect unexpectedly. I use "episode" and "scene" designations in the titles to invoke the sense that they are scenes taken from an actual movie. The titles also create continuity between the scenes and characters.

'As I continue to develop my skills and techniques, I hope to pursue freelance work involving science fiction and fantasy subjects.'

jjsmlee@chartermi.net
www.renderosity.com/homepage.ez?Who=jjsmlee

Ep 02 Sc 20: Introduce Claude
2001
One of a series of illustrations for a story concept
3207 pixels x 1886 pixels
Software and platform: Bryce 4, Poser 4, Corel PhotoPaint 8, Windows

At a busy metropolitan bus station, our heroine encounters a desperate mouse named Claude. This is the beginning of their adventure. The background buses were created using Bryce Boolean modelling tools. This was my first attempt to incorporate multiple Poser figures in a single scene.

Ep 02 Sc 23b: Claude's Explanation
2001
One of a series of illustrations for a story concept
3200 pixels x 1882 pixels
Software and platform: Bryce 4, Poser 4, Corel PhotoPaint 8, Windows

Claude and our heroine come to an understanding. However, neither is aware of the two mysterious characters in the background who are about to unleash mayhem on the bus. This was a study to show up close the story's main characters. Claude's plastic rocket pack (non-functional) and birthday hat are his trademark.

Ep 10 Sc 39: Captured
2003
One of a series of illustrations for a story concept
2143 pixels x 3213 pixels
Software and platform: Bryce 5, Poser 5, Corel PhotoPaint 10, Rhinoceros, Windows

Claude and our heroine become separated as they try to evade the spider-like denizens of the caverns. She and the other bus passengers are captured and await a horrible death. Fortunately, Claude appears just in time. The 'webbing' in this illustration was hand-painted in PhotoPaint.

Ep 10 Sc 30: In the Szaara Caverns
2002
One of a series of illustrations for a story concept
3031 pixels x 1777 pixels
Software and platform: Bryce 4, Poser 4, Corel PhotoPaint 8, Windows

Claude and our heroine find themselves stranded in the desert after the bus on which they were travelling has crashed. Finding shelter from the sun in some nearby caverns, they realize they are not alone.

Ep 14 Sc 30: Behind the Door
2001
One of a series of illustrations for a story concept
3220 pixels x 2016 pixels
Software and platform: Poser 4, Bryce 4, Corel PhotoPaint 8, Windows

Behind the door is an army of aliens. This was my first Bryce illustration. All the props and background elements were created using the modelling tools (Boolean objects) in Bryce. The scene objects were re-used in a subsequent illustration that shows the action from a different angle. The alien textures were hand-painted in post-production.

Ep 14 Sc 31b: Descend Like Flies
2001
One of a series of illustrations for a story concept
3220 pixels x 1985 pixels
Software and platform: Poser 4, Bryce 4, Corel PhotoPaint 8, Windows

The aliens and their flying craft surround the heroine and Claude as they attempt an escape. (You can see Claude as a tiny speck on the ground in front of our heroine.) To convey a sense of the immense scale of the hangar without a large 3D model (which would have created a lighting nightmare), I created a 2D render of a scene and used it as a background texture.

Ep 39 Sc 41: The Unlikely Seduction
2002
One of a series of illustrations for a story concept
3250 pixels x 1950 pixels
Software and platform: Poser 4, Bryce 5, Corel PhotoPaint 8, Rhinoceros, Windows

Primarily a study to see if I could create alien characters using a combination of Rhinoceros and Poser. Although much is hidden because of the foreground elements, the room is modelled in great detail, complete with a bandstand and bar, and there's a terrific view of the planet around which they're orbiting.

Ep 40 Sc 02: Flight to the City
2002
One of a series of illustrations for a story concept
3300 pixels x 2062 pixels
Software and platform: Poser 5, Bryce 5, Corel PhotoPaint 8, Rhinoceros, Windows

Teaming up with a band of new characters, our heroine and Claude hitch a ride to a city tucked away in the mountains. This was my first attempt at an expansive outdoor scene (where I couldn't rely on dark shadows and dim lighting to hide mistakes). The scene elements, including the city, clothing props and riding craft, were modelled in Rhinoceros. Motion blur and lens flare were created in post-production with PhotoPaint.

Ep 40 Sc 02b: Flight to the City (cont.)
2002
One of a series of illustrations for a story concept
3200 pixels x 1996 pixels
Software and platform: Poser 5, Bryce 5, Corel PhotoPaint 8, Rhinoceros, Windows

View from another angle of the same scene as above to reveal more ship details and texturing.

Ep 12 Sc 25: Threats Against a Dignitary
2003
One of a series of illustrations for a story concept
3200 pixels x 1888 pixels
Software and platform: Poser 5, Bryce 5, Corel PhotoPaint 10, Rhinoceros, Windows

This scene takes place in the palatial home of a dignitary who now realizes the extent of the deceit and betrayal within his own ranks. Our heroine and Claude find themselves caught in the middle. The dignitary's room was modelled in great detail using Rhinoceros, including furniture elements and robot sentry. The 'embroidery' details on the clothing were hand-painted in post-production using PhotoPaint.

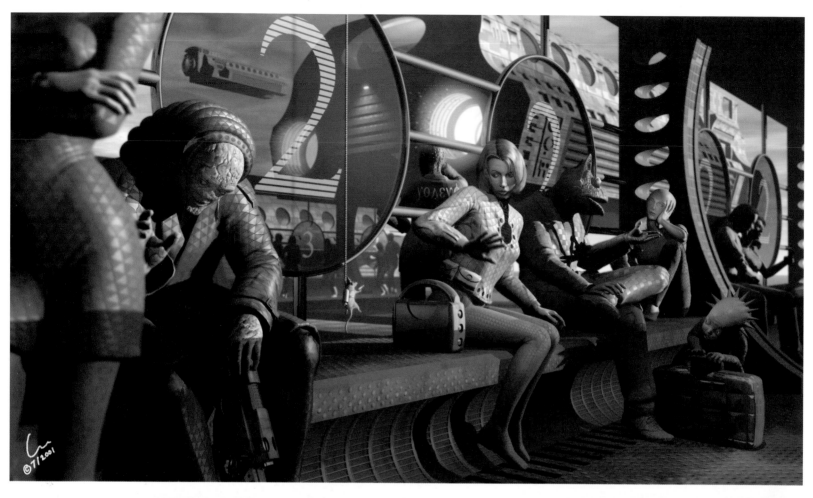

▲ Ep 02 Sc 20:
Introduce Claude

Ep 02 Sc 23b: ▶
Claude's Explanation

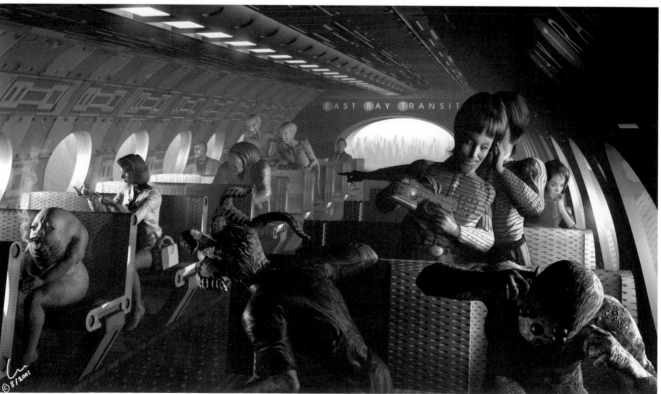

Ep 10 Sc 39: Captured ▶

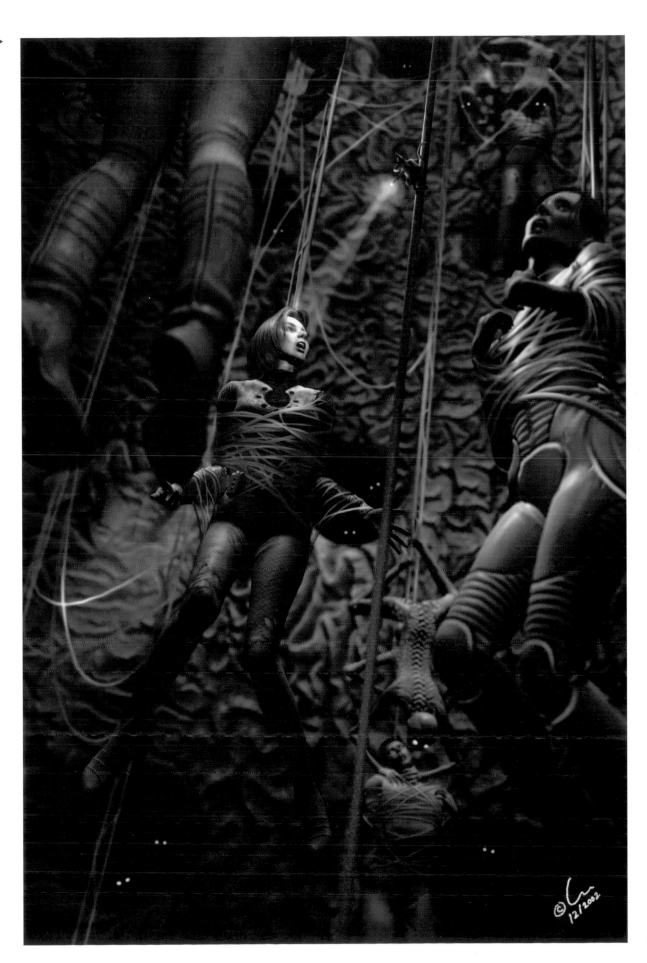

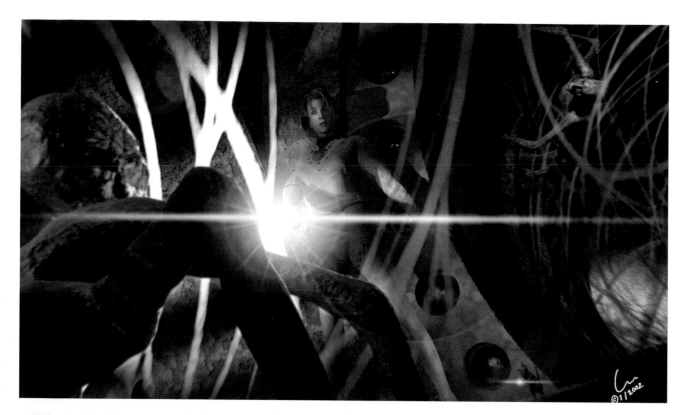

◄ *Ep 10 Sc 30:*
In the Szaara
Caverns

▼ *Ep 14 Sc 30:*
Behind the Door

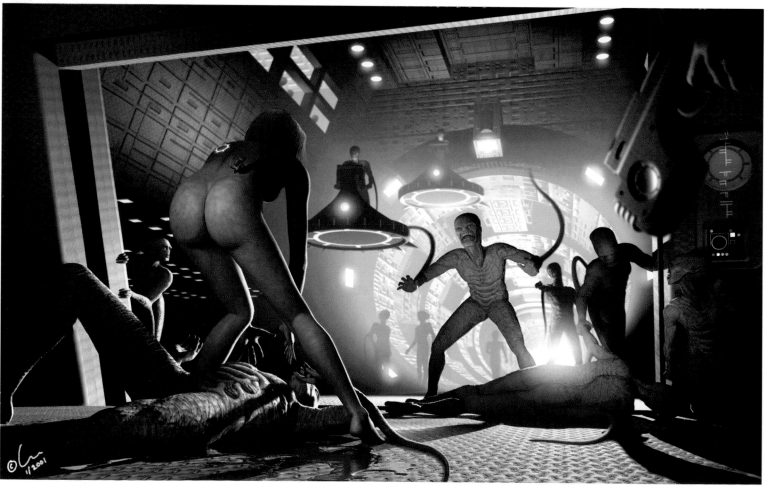

Ep 14 Sc 31b: ▶
Descend like Flies

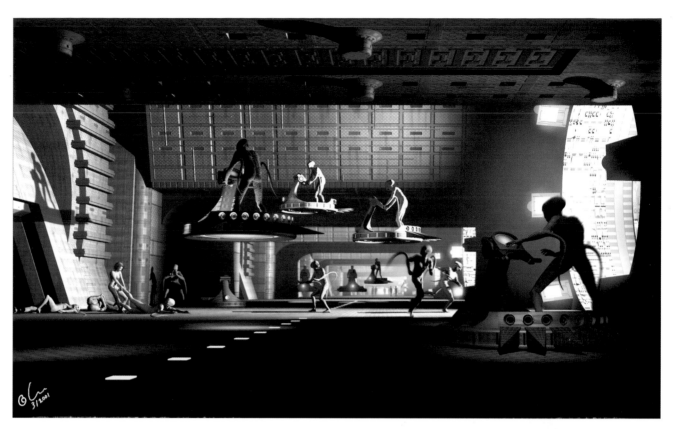

Ep 39 Sc 41: ▼
The Unlikely Seduction

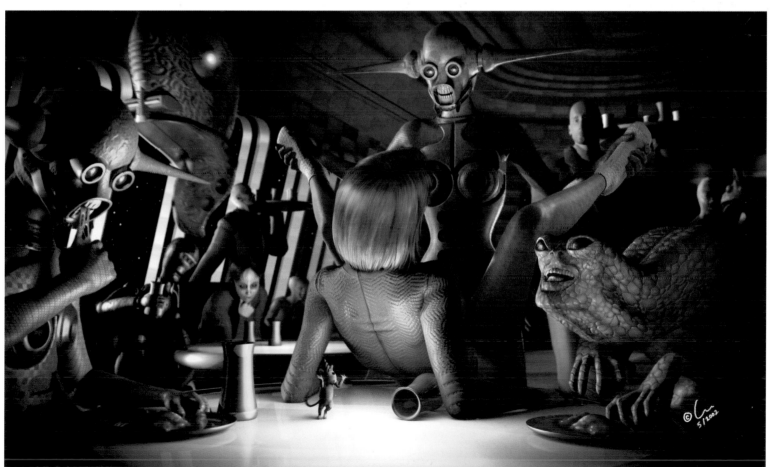

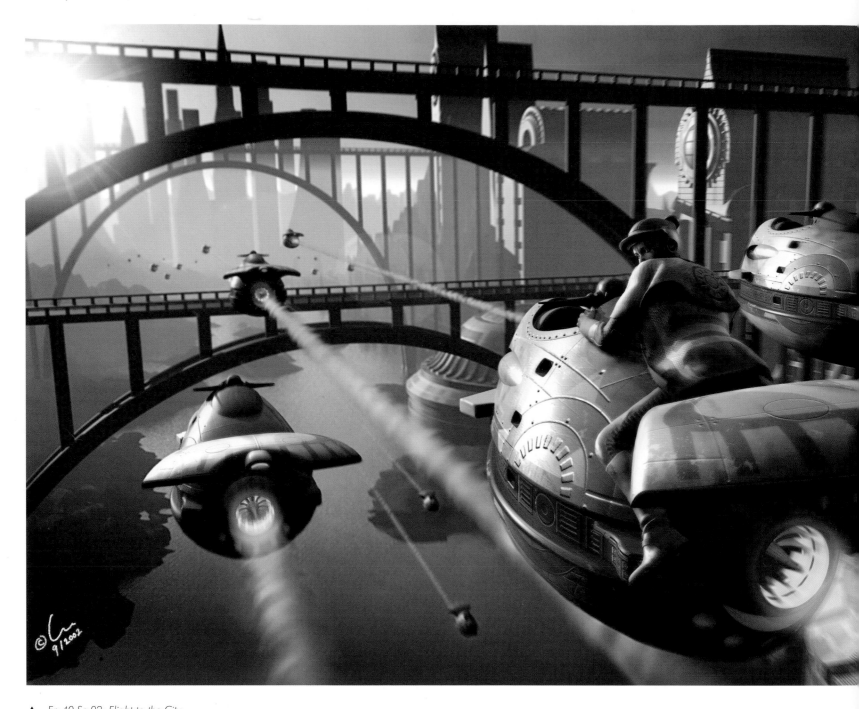

▲ *Ep 40 Sc 02: Flight to the City*

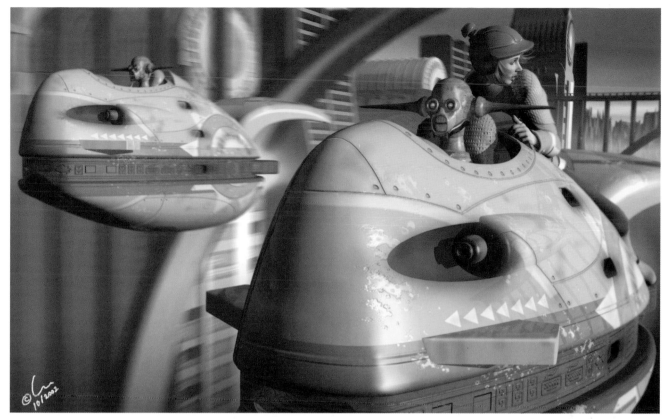

02b: Flight to the City (cont) ▶ ▲

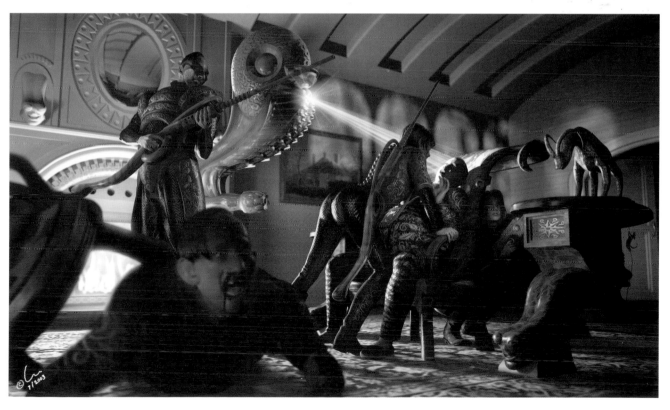

Ep 12 Sc 25: Threats Against a Dignitary ▲

ELIZABETH LEGGETT

Elizabeth Leggett (Archway)

Elizabeth Leggett writes: 'Prior to finding my place in professional art, I worked as a tractor manifold inspector, assistant theatrical director, middle-school teacher, maid and collectibles salesperson in Wiesbaden, Germany – all this after getting a BA in English and Psychology and a post-baccalaureate certification in Education!

'I did commissioned work for collectors for many years before launching into art full-time. In 2000, two local galleries contracted to display my work. After attending Dragon*Con the following year, I was lucky enough to be hired as an illustrator by Plan 9 Publishing. That led to my first collaboration with Pete Abrams, creator of *Sluggy Freelance*. I designed three illustrations based on characters from his strip. Zoe and Gwenn were featured in his seventh book, *A Very Big Bang*. Soon after, I worked for White Wolf Publishing on their Dark Ages supplement, *Ashen Cults and Vampire Dark Ages: Europe*. Mystic Station Designs contracted two gaming covers and ten NPC card designs.

'I moved from print to gaming software that same year. I signed with Sojourn Development as a concept artist for the upcoming MMORG *Glympse* (due out in late 2004). Soon after, Laughing Pan Studios, led by Phil Brucato, hired me to do twelve illustrations, the logo and the game icons for *Deliria*. T-shirts featuring my work are on sale from Attic Wear.

'I owe many people a great deal of thanks for this amazing ride, but most of all I owe my husband for his patience and support.'

www.renderosity.com/homepage.ez?Who=Archway

Storm Spirit
2002
Illustration for *Deliria: Faerie Tales for a New Millennium* (Laughing Pan Productions)
3150 pixels x 1575 pixels
Software and platform: Photoshop 7, Windows Me

The East Coast of the USA is known for its hurricanes and its strong women. Underestimating either can be really foolish! When Phil asked me to illustrate a female spirit who created storms, I imagined the quiet seething moment that heralds danger right before the sky erupts . . . or a woman lets loose her fury.

The Glitch
2002
Illustration for *Deliria: Faerie Tales for a New Millennium* (Laughing Pan Productions)
1575 pixels x 3150 pixels
Software and platform: Photoshop 7, Windows Me

Phil asked me to illustrate a computer demon – one that specifically made computers freeze up. The original title was *The Freeze*, but audre renamed it *The Glitch* and I stuck with the new name. A Glitch is someone everyone who works on computers has met at one time or another . . . and yelled at!

Autumn's Fortune
2000
Art print, Plan 9 Publishing
2127 pixels x 3150 pixels
Software and platform: Photoshop 5, Windows 98

I have often been lured into the mystique of fae, particularly that ethereal beauty the faeries are said to possess. The happiest accident with this piece came with the collar ruff. I had done a piece that did not work, but there was this section of light that intrigued me. I cut it from the doomed piece and used it as the basis for the collar.

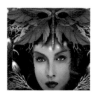

Oberon and Titania
2001
Art print, Mystic Stations Design
1895 pixels x 3150 pixels
Software and platform: Photoshop 7, Windows 98

I am a huge Shakespeare fan and I love unusual masks. My husband and I were on a cruise to renew our vows, and this piece sort of demanded to be created.

Autumn Muse
2002
Personal work
1969 pixels x 3150 pixels
Software and platform: Photoshop 7, Windows Me

Most of the art I do is on commission. I am usually under tight deadlines that require fairly instant creativity. Once a year, my muse requires a sort of payment for all that instant creativity, and so I design a portrait of her as sort of a thankyou. It seems to have worked so far!

Yin Yang
2001
Art print, Plan 9 Publishing
3150 pixels x 3157 pixels
Software and platform: Photoshop 5, Windows 98

A very dear friend asked me if I had ever seen a really unusual yin yang symbol; he was looking for something 'different'. I created this piece as part of that quest.

Summer Muse
2003
Attic-Wear products
1890 pixels x 3150 pixels
Software and platform: Photoshop 7, Windows Me

Originally I wanted to make this a daytime piece. I had visions bouncing around in my skull of flying wheat and grass and so on. However, once I'd done the face I realized that bright light would be too harsh.

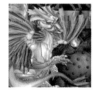

Clutter Dragon
2001
Art print, Plan 9 Publishing
3150 pixels x 2291 pixels
Software and platform: Photoshop 5, Windows 98

Dragons are enormously popular with fantasy and science fiction aficionados, a good many of whom also dabble in role-playing games. The props associated with gaming are distinct and easily recognizable. That was the inspiration for this piece.

Zoe's Zingers
2002
Art print, Plan 9 Publishing; character illustration for Pete Abrams for his comic *Sluggy Freelance*
3150 pixels x 1969 pixels
Software and platform: Photoshop 7, Windows Me

I met Pete at Dragon*Con 2001 and he purchased a few prints from me. I ended up joining the Plan 9 Publishing team at that same convention. He posed the idea of doing his characters in my style. I jumped at the chance! I ended up doing three of his female characters and one of his males. The male never quite hit the mark, but the ladies did.

Scarves
2001
Art print, Plan 9 Publishing
3150 pixels x 2291 pixels
Software and platform: Photoshop 5, Windows 98

Originally, this was a chance for me to play with skin tones and fabrics. I had not expected her hair to look as if it were transforming into scarves, but it proved this was what many viewers thought. You never know what your audience will see in your work.

The Enchanted Ones
2001
Art print, Plan 9 Publishing
3150 pixels x 2291 pixels
Software and platform: Photoshop 5, Windows 98

Every redhead has distinctive colouring in both her hair and her skin. I wanted to demonstrate a mastery of those variations in this piece. The fact that it is mildly erotic was an unexpected bonus!

▲ *Storm Spirit* *The Glitch* ▶

◄

Oberon and Titania

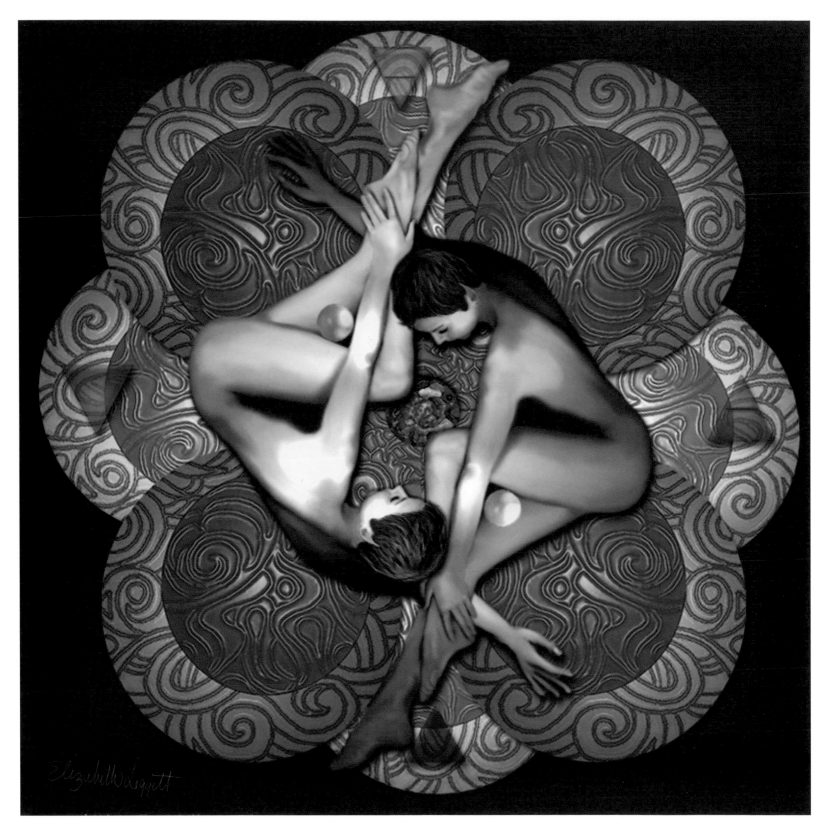

▲ *Yin Yang*

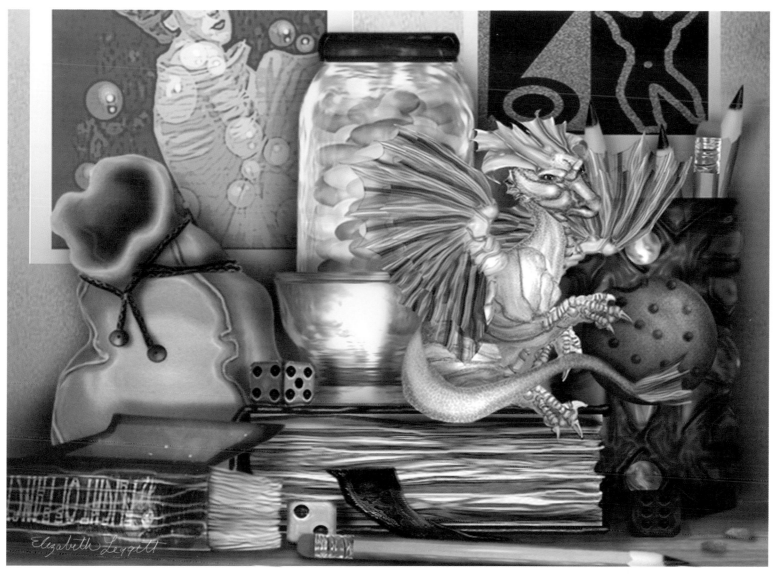

▲ Clutter Dragon

◄ Scarves

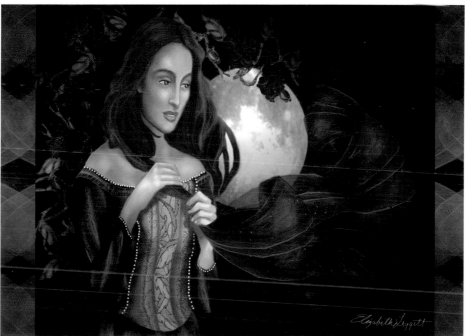

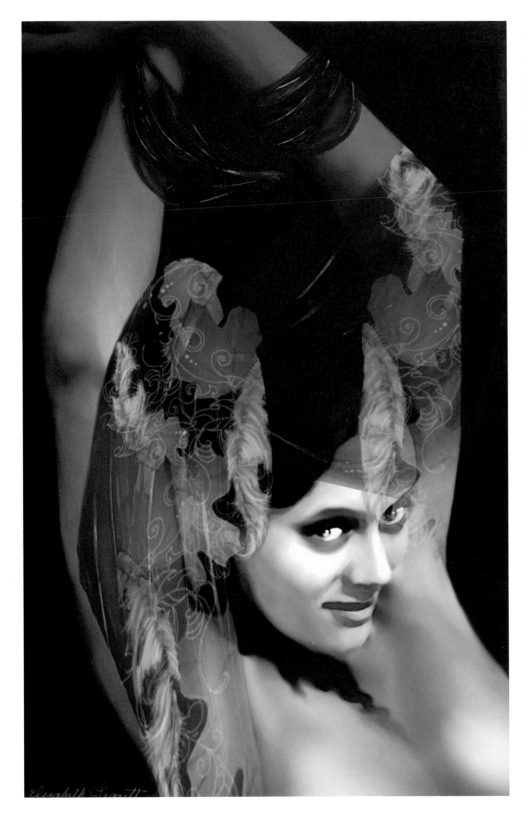

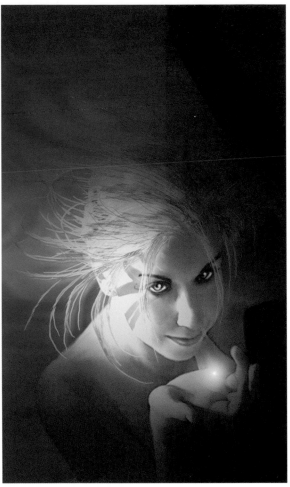

▲ *Summer Muse*

◄ *Autumn Muse*

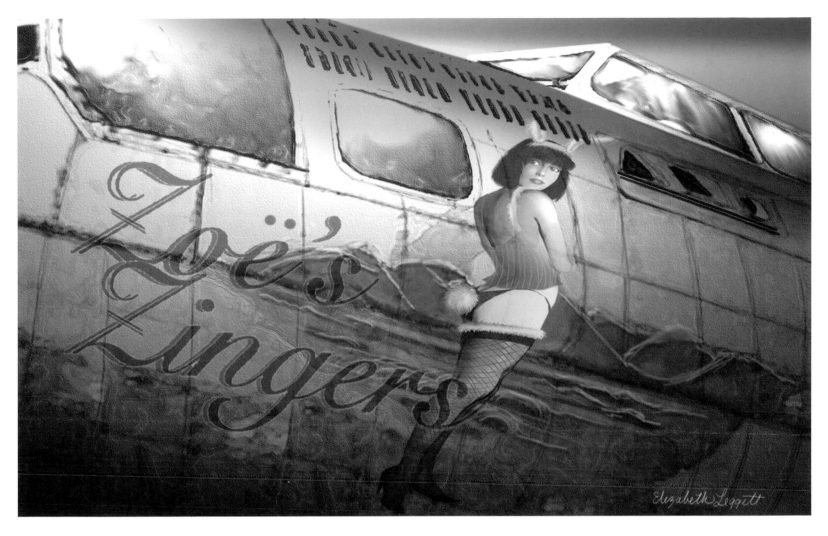

▲ Zoë's Zingers

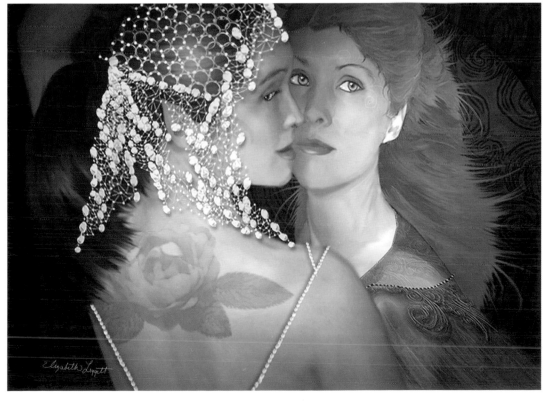

◀ *The Enchanted Ones*

DUNCAN LONG

Duncan Long

Duncan Long writes: 'I endeavour to craft illustrations which explore the dark and dusty corners of the mind, combining myth and reality, stirring in some of our innate fears, and maybe adding a psychological twist here and there along the way. We're living in an almost surreal age, when the human spirit and the machinery of science and politics often collide, for good or ill, and I hope to capture both the horror and the joys of this time.

'The tools of the digital artist accomplish what is all but impossible with ink or paint. In the mid-1990s I started using the computer for illustrations, and I've never looked back. One day all my traditional drawing and painting tools were boxed, and there they've remained – like the toys of my youth, little more than curiosities.

'Digital imagery also permits greater realism (when needed) as well as faster fabrication. Ideas that were impracticable in the past are now doable; what once required weeks can now often be generated in hours. Further, the quality of the finished product can have exactly the colours the artist wants, and sketches can be executed with enough realism and detail to rival a photograph – a snapshot of the wildly impossible!

'There's also a synthesis between artist and computer that is very different from that between artist and traditional painting tools. Some of today's art software acts as a sort of digital assistant, rather in the same way that the Renaissance apprentice did the grunt work for the Master, leaving the latter to produce more. Or the computer can become a muse or a collaborator, regularly sparking innovation and random elements that inspire the artist to explore new paths that would never have been travelled otherwise.'

www.duncanlong.com

Dance Macabre
2003
Personal work
2068 pixels x 3200 pixels
Software and platform: Corel PhotoPaint, Poser

Inspired by classical composer Saint-Saëns's orchestral piece *Danse Macabre*, this pictures Death tuning up for a midnight performance. The skeleton was created in Poser, then reformed and detailed in PhotoPaint, where the violin and bow were also painted. Since the bow of every violinist I've ever seen has had some stray horse-hairs hanging from it, I added a few faint ones here, too.

Barbarian at the Gate
2003
Demonstration piece
2071 pixels x 3200 pixels
Software and platform: Corel PhotoPaint, Poser

Highly modified Poser figure which I hand-painted for a Goth look, with highlights to give the appearance of a spotlight; a second copy was flattened to form an apparent shadow behind her. The sky, originally a digital photo, was colour-shifted and somewhat desaturated for a 'night' look; clouds were added here and there for balance. Distant trees and fog were painted in behind the gate and figure.

Dreams of Ghosts and Space
2003
Demonstration piece
2071 pixels x 3200 pixels
Software and platform: Corel PhotoPaint, Bryce

A composite, with a sunset photo I took forming the lower half of the picture, a Flaming Pear 'Flood' creating the water reflection. The space station and upper clouds were rendered in Bryce. Stars and lights, plus a pair of spaceships, were later painted for added detail. The face, figure and flowing hair were done as a separate object, with a gradual transparency for a ghostly look.

An Evening Nightmare
2002
Personal work
3088 pixels x 3200 pixels
Software and platform: Corel PhotoPaint, Poser

A composite from earlier artwork I'd created: a
highly modified 'lady' modelled in Poser coupled
with a castle/sky I painted digitally, along with stars.
The monster's face started as a photo I'd taken of
maple bark; a bit of shading formed it into a face.
The sky was a gradient with the crescent moon
fashioned using a round mask pulled to one side;
a lens flare plug-in formed the sun.

Riddle of the Sphinx
2003
Demonstration piece
2071 pixels x 3200 pixels
Software and platform: Corel PhotoPaint, Bryce, Poser

A single sphinx was created in Poser and then
exported to Bryce as a DXF model that was
duplicated several times to create a row of statues.
A Bryce pyramid and cobblestone surface completed
the effect. The sky was done in PhotoPaint, along
with the birds, and the girl was posed to mimic the
sphinxes, hopefully giving some balance through
the repeated patterns as well as a bit of irony.

Evening Bike Ride
2001
Cover illustration for *The Best Book of Bizarre but
True Stories Ever!* by Mike Flynn (Carlton)
3200 pixels x 2436 pixels
Software and platform: Corel PhotoPaint, Terragen

The background – including the sky, sand dunes,
water and sun – was done in Terragen and then
imported into PhotoPaint and colour-corrected.
A Poser skeleton was then arranged on a DXF bicycle
and composited into the picture, modified, and
reshaped here and there. Finally DigArt grass was
'sprayed' as an object and darkened to add a bit
of realism.

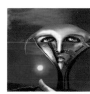

The Unusual Suspect
2003
Cover comp for the book *The Shoe Shine Boy* by
David Mucci
2071 pixels x 3200 pixels
Software and platform: Corel PhotoPaint
A straight digital painting done pretty much the
way a regular painting would be – but with electrons
instead of paint, digital pen rather than brushes.
(The final cover will sport Nazi boots and the skeletal
hand of a Holocaust victim.)

Filthy Habits
2001
Personal work
2121 pixels x 3200 pixels
Software and platform: Corel PhotoPaint, Poser

Originally two different Poser renders, which I
combined into a single piece. The top of the lady's
head was cropped and then the back of her skull
painted in to give the illusion of the proverbial 'open
mind'; some 'smearing' formed the cigarette holders.
Cigarette, smoke and sunglasses were painted in.
The woman's original face didn't seem compelling
enough, so I painted a new one over the original.

Legends
2003
Done originally for a CD cover
2287 pixels x 3200 pixels
Software and platform: Corel PhotoPaint

This started as a composite with three photos: a
revolver, a mahogany table and a sky shot, the latter
being colour-shifted and contrasted with a painted-in
sun. The face began as a digital painting, which I
put through a pole filter to warp it, then I painted a
metal grill and a rock; I created the horns with a
smear brush. The smoke and hand were painted
as objects. Finally everything was shaded and
shadowed.

Hunter Killer
2002
Demonstration piece
2052 pixels x 3200 pixels
Software and platform: Corel PhotoPaint, Bryce, Poser

The sky and grass were created from two different
digital photos I'd taken; the grass was carefully
masked to permit seeing through it. The Poser
figure was exported as a DXF file, imported into
Bryce, and rendered with a chrome finish, then
masked and placed as an object behind the grass.
The antennae/ears, gun and glowing eyes were
painted and the figure modified for better contrast
and 'reflection'.

▲ Barbarian at the Gate

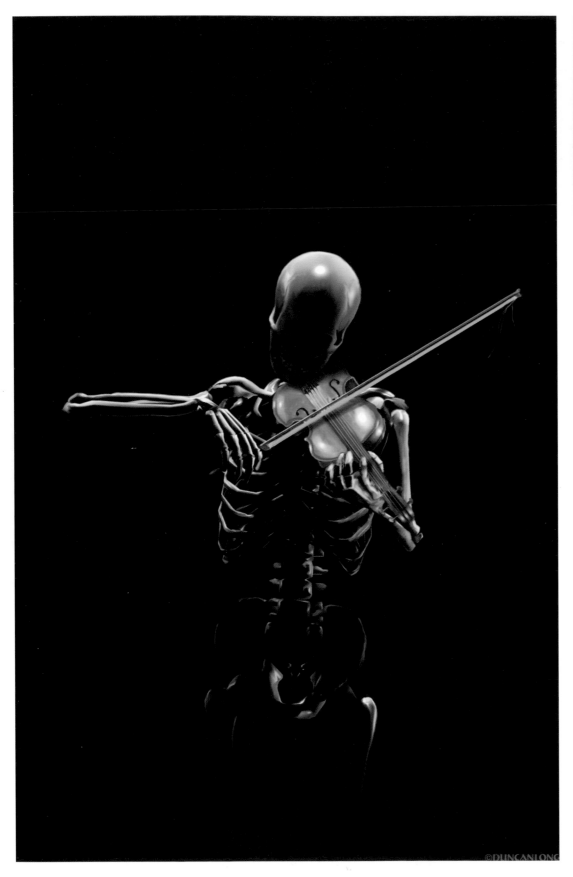

◀ Dance Macabre

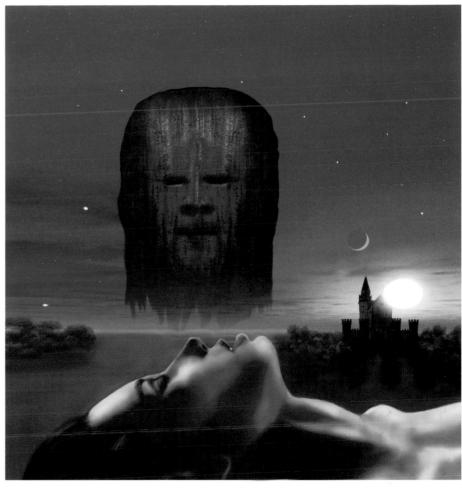

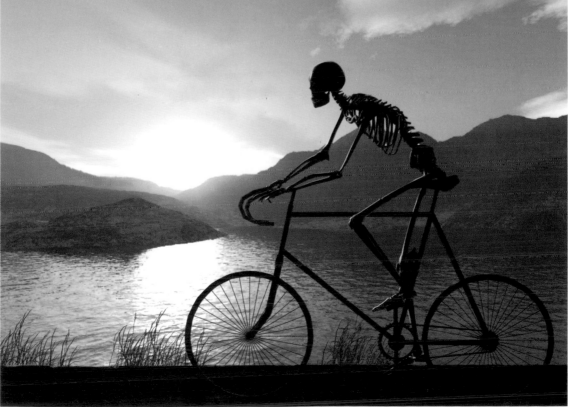

▲

*Dreams of
Ghosts and
Space*

▲

*An Evening
Nightmare*

◄

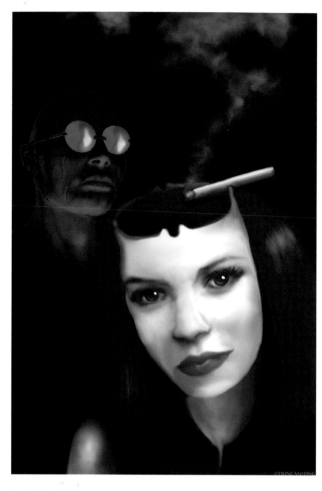

▲ Filthy Habits

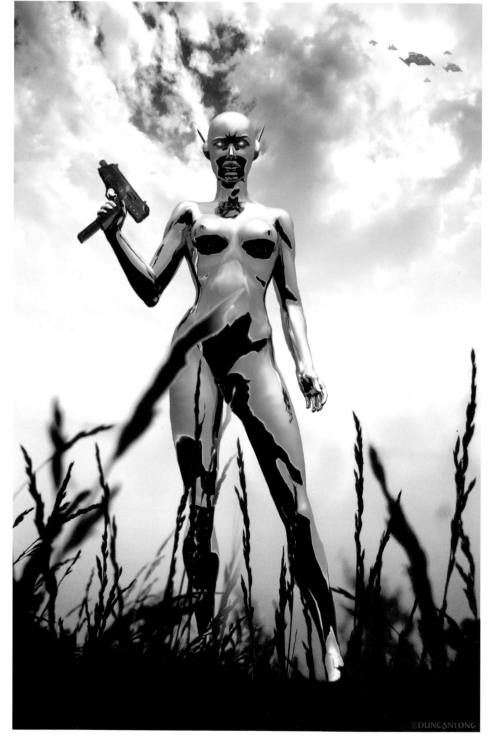

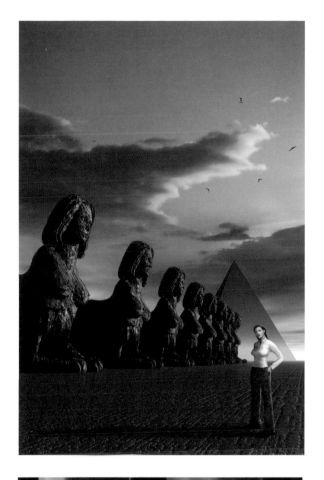

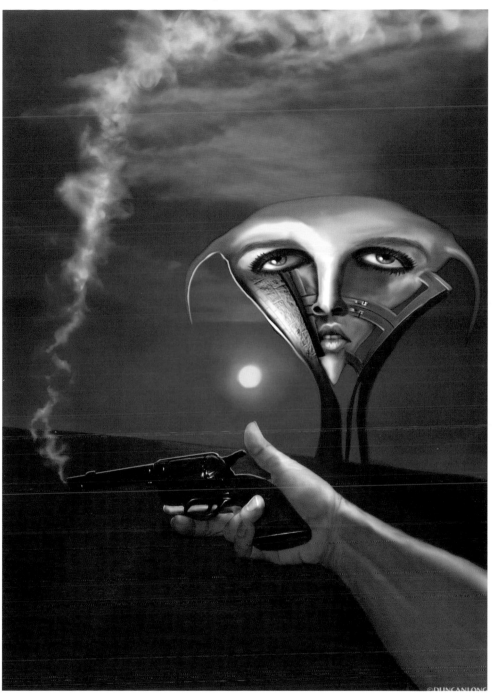

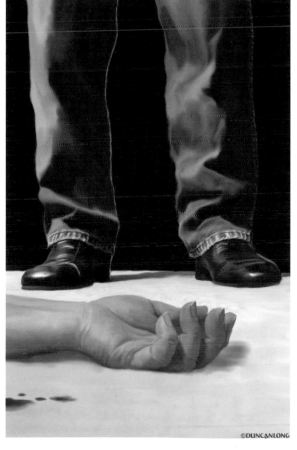

Legends ▲

◄ *The Unusual Suspect*

RON MILLER

Ron Miller

Ron Miller writes: 'I am an illustrator and author specializing in astronomical subjects. I have the uncommon luxury of being able to illustrate my own books or write books to go with my illustrations, as the case may be. To date, there have been more than thirty of these books, from the 1982 Hugo-nominated *The Grand Tour* to the 2002 Hugo-winning *The Art of Chesley Bonestell* (done with Frederick C. Durant III). I have recently completed writing and illustrating a ten-book young adult series about the Solar System which won the American Institute of Physics Award for Excellence in Writing in Physics and Astronomy. I have also written (and illustrated, naturally!) six novels: one historical fantasy based on a character from *Orlando Furioso*, four steampunk fantasies and (of all things) a hard-boiled '50s detective story.

'In addition to my book work, I have been a production illustrator and designer for several motion pictures and have designed US postage stamps. Several new book projects are currently in the works, including one about movie special effects and a collection of fantasy/surrealistic artwork called *Elemental Woman*.

'I began working digitally less than three years ago, and the novelty has yet to wear off!'

www.black-cat-studios.com

Air
2002
One of 100 illustrations for *Elemental Woman*, a book in progress
3850 pixels x 4900 pixels
Software and platform: Photoshop, Windows XP

Coprates
2002
Interior illustration for *Mars* (Millbrook Press)
2975 pixels x 7700 pixels
Software and platform: Photoshop, Terragen, Windows XP

Part of the great Vallis Marineris canyon system on Mars, created for the *Mars* volume of my ten-book series on the Solar System. Like many of the illustrations done for these books, this made extensive use of the remarkable terrain-generating program Terragen, being developed by Matt Fairclough.

Death
2002
One of 100 illustrations for *Elemental Woman*, a book in progress
3850 pixels x 4900 pixels
Software and platform: Photoshop, Windows XP

The Fox
2003
One of 100 illustrations for *Elemental Woman*,
a book in progress
2975 pixels x 3850 pixels
Software and platform: Photoshop, Windows XP

Coyote
2003
Frontispiece for the novel *Coyote*, by Allen Steele
(Easton Press)
2100 pixels x 3150 pixels
*Software and platform: Photoshop, Terragen,
Windows XP*

Polar Halo on Mars
2002
Interior illustration for *Mars* (Millbrook Press)
3150 pixels x 2434 pixels
*Software and platform: Photoshop, Terragen, Halo,
Windows XP*
One of the nearly 100 illustrations done for my
ten-book young adult series about the Solar System.
This one employed not only the amazing terrain-
generating program Terragen but also Halo, a
program devised by meteorologists Les Cowley and
Michael Schroeder that allows me accurately to
create the appearance of atmospheric optical
phenomena created by exotic materials, such as
crystals of CO_2, methane, ammonia, etc.

Medea
2003
One of 100 illustrations for *Elemental Woman*,
a book in progress
2975 pixels x 3850 pixels
Software and platform: Photoshop, Windows XP

Mars Channel
2003
Interior illustration for *Mars* (Millbrook Press)
2975 pixels x 3850 pixels
*Software and platform: Photoshop, Terragen,
Windows XP*

An illustration for the *Mars* volume of my ten-book
young adult series about the Solar System.

Water
2002
One of 100 illustrations for *Elemental Woman*,
a book in progress
3850 pixels x 4900 pixels
*Software and platform: Photoshop, Terragen,
Windows XP*

Water, sky and islands were generated by Terragen.
The most difficult part was creating the drops of
water that apparently lie on the surface of the
artwork. These were done by printing a copy of the
illustration, sans drops, and placing it under a sheet
of glass, then putting water on the glass with a
dropper. Once I had these placed and shaped as
I wanted them, I photographed the entire setup with
a digital camera. Finally the drops were cut out in
Photoshop and set into the original artwork. This
way I not only got a realistic appearance for the
drops themselves but obtained the distortion of the
underlying image. (One droplet, though, was
hand-painted from scratch. I hope it's difficult to
tell which!)

Ancient Flooding on Mars
2003
Interior illustration for *Mars* (Millbrook Press)
2975 pixels x 3850 pixels
*Software and platform: Photoshop, Terragen,
Windows XP*

An illustration for the *Mars* volume of my ten-book
young adult series about the Solar System.

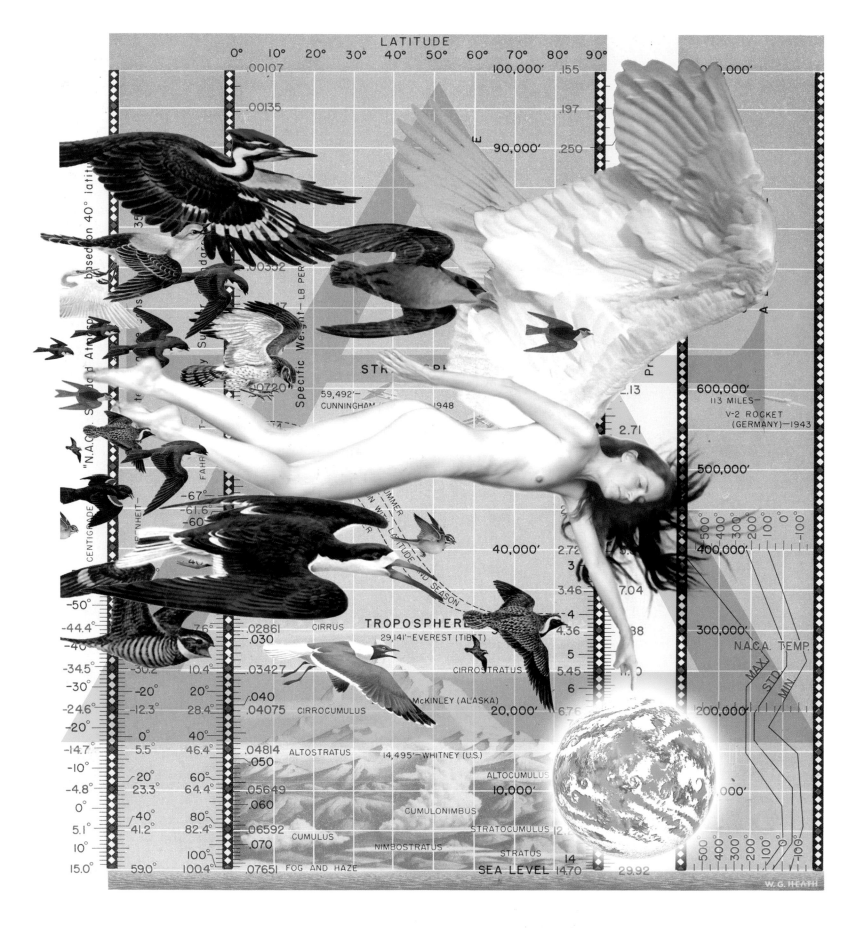

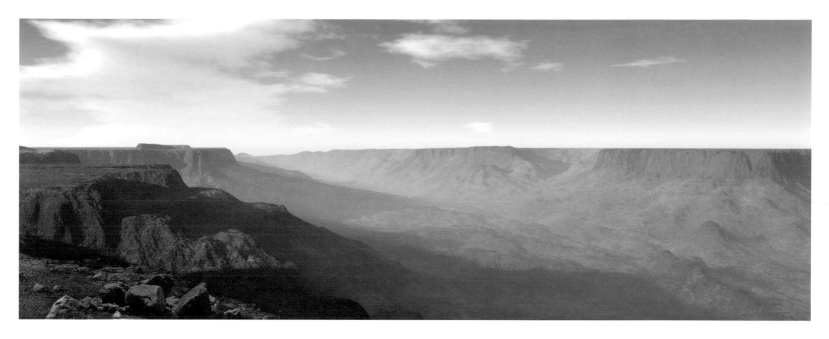

▲ Coprates

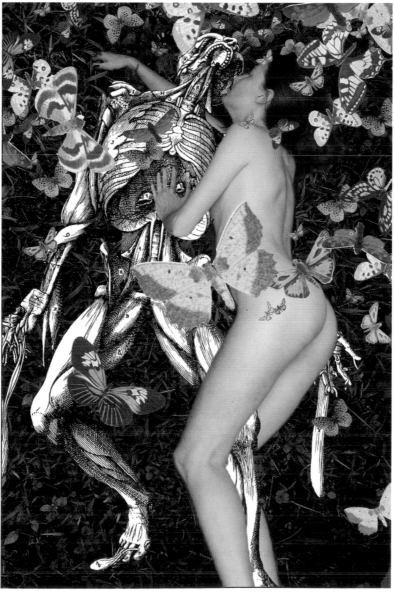

◄ Death

◄ Air

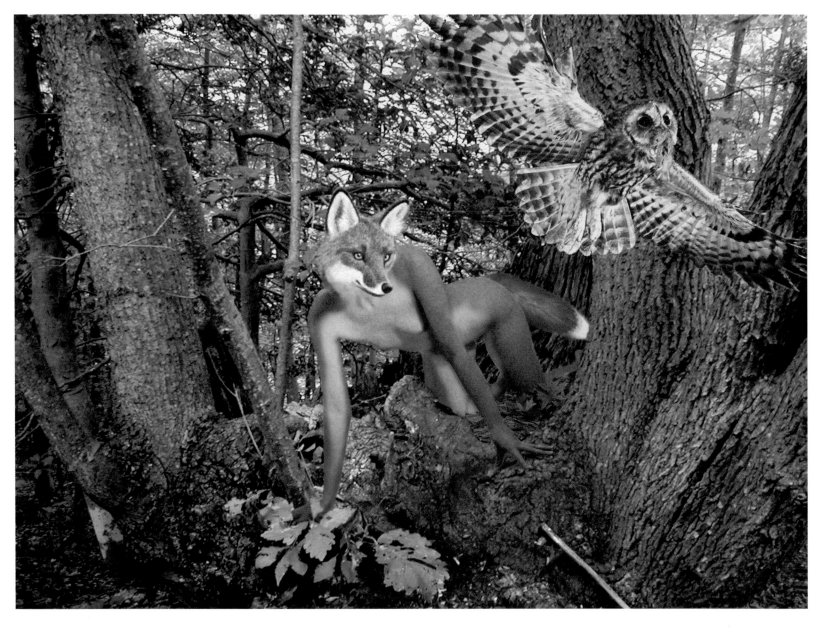

▲ *The Fox*

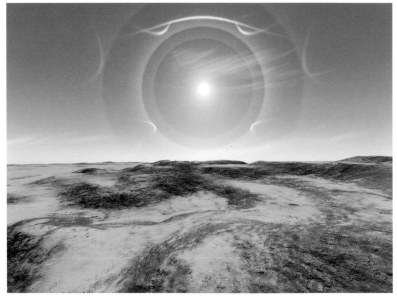

Polar Halo on Mars ▶

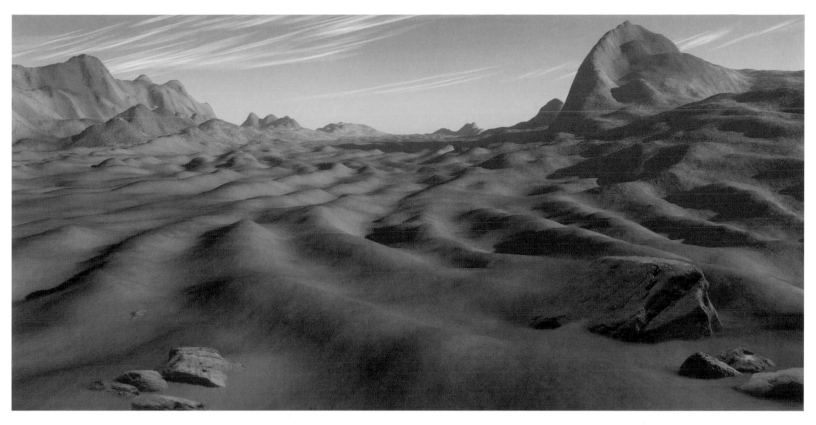

▲ *Mars Channel*

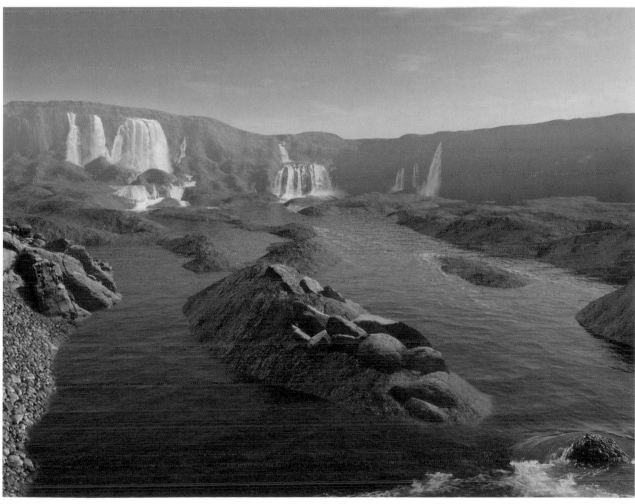

▶

Ancient Flooding on Mars

◄ *Coyote*

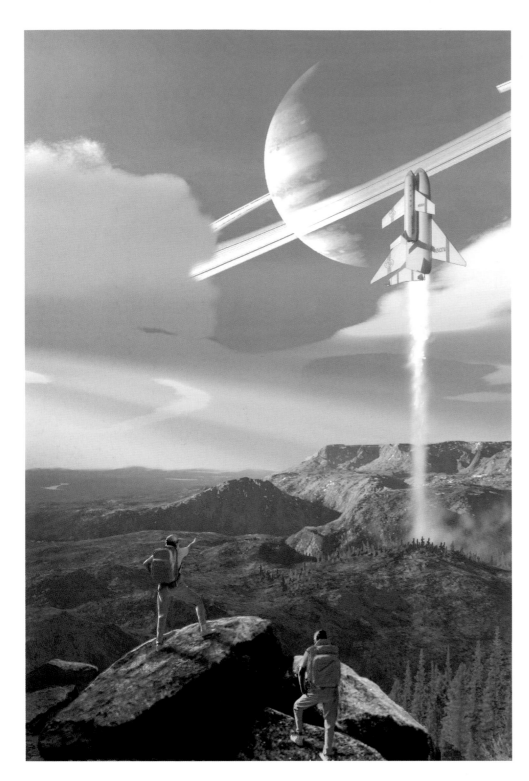

Water ►

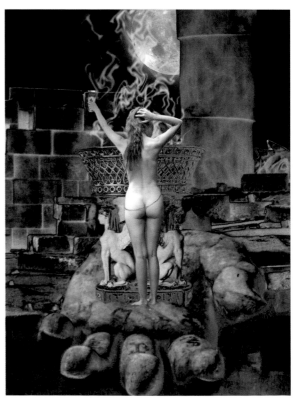

Medea ►

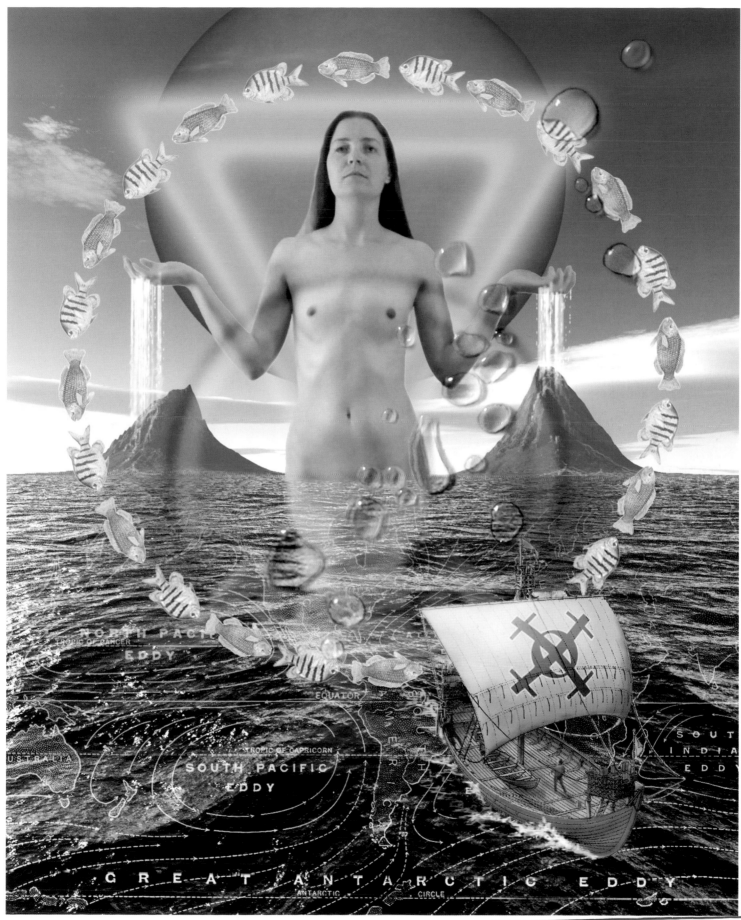

SOCAR MYLES

Socar Myles

Socar Myles writes: 'If there's one thing I want to communicate through my art it is definitely that creepy sense of "something not quite right". My preferred genre, therefore, is horror – but most of the time I prefer subtle horror: I'd rather paint the instant *before* the zombie jumps out of the closet than the zombie itself. When people look at my art, I want them to see its beauty first, and only later notice the hidden splash of blood or the steely glint in the figure's eye. Rats are among my favourite subjects to paint, which also helps to get the unsettling effect across. While I happen to think rats are cute as all get-out, a lot of people think very much otherwise!

'Second to horror, I love painting landscapes and animals, so I have a lot of commissioned pet portraits and scenery painting in my portfolio.'

www.gorblimey.com

The Vendetta
2002
Self-portrait
4000 pixels x 5333 pixels
Software and platform: Adobe Photoshop 6, Windows XP

I painted myself in a colder light for this self-portrait. Clearly I'm contemplating revenge!

The Revenant
2002
Tarot card
2481 pixels x 4146 pixels
Software and platform: Adobe Photoshop 6, Windows XP

This gloomy tarot card, inspired by Elvira's madness in Bellini's *I Puritani*, is the Hanged Man.

Death Scenes IV – Dusk Mountain Oleander
2003
Background art for *Thundercats/Battle of the Planets* (Wildstorm Comics)
4500 pixels x 1603 pixels
Software and platform: Photoshop 7, Windows XP

Painted as comic-book background art, one of a series of four each containing a poisonous plant (in this case, oleander).

Evening of Dandelions and Fireflies
2002
Commissioned pet portrait
4000 pixels x 2000 pixels
*Software and platform: Photoshop 6,
Windows XP*

A commissioned portrait of a cat in a fanciful
forest setting.

Tanner's Butterflies
2002
Commissioned pet portrait
2000 pixels x 4000 pixels
*Software and platform: Adobe Photoshop 6,
Windows XP*

Inspired by the art of days gone by, this was
commissioned as one of a series of whippet portraits.

Dead Bird Tree I Love You
2002
Personal work
2133 pixels x 3200 pixels
*Software and platform: Photoshop 6,
Windows XP*

A bizarre piece done just for fun as an
experiment with colour.

Twitch!
2000
Portfolio piece
1997 pixels x 3200 pixels
*Software and platform: Photoshop 5.5,
Windows XP*

This 'oldie but goodie' was one of my first
Photoshop paintings ever, done way back in 2000.
'Twitch' was the cute little rat's name.

Mask of Pain
2002
Portfolio piece
1969 pixels x 3200 pixels
*Software and platform: Photoshop 6,
Windows XP*

A ratty little illustration inspired by Verdi's *Un
Ballo in Maschera*.

The Rat Queen's Wedding Party
2002
Self-portrait
3300 pixels x 4200 pixels
*Software and platform: Photoshop 6,
Windows XP*

My self-portrait as a bride. All those rats
are there to cheer me on. (Hey, weddings are
stress-filled days!)

Happy Sunset Birds Dance
2002
Interior illustration for a forthcoming book
2133 pixels x 3200 pixels
*Software and platform: Photoshop 6,
Windows XP*

Commissioned for a modern fantasy/horror
trade paperback by Summer Threlkeld.

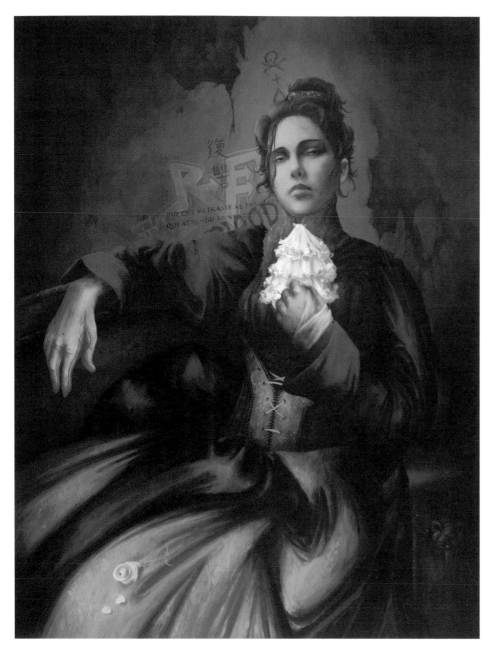

▲ *The Vendetta*

The Revenant ▶

▲ ▲ *Death Scenes IV – Dusk Mountain Oleander*

Evening of Dandelions and Fireflies ▲

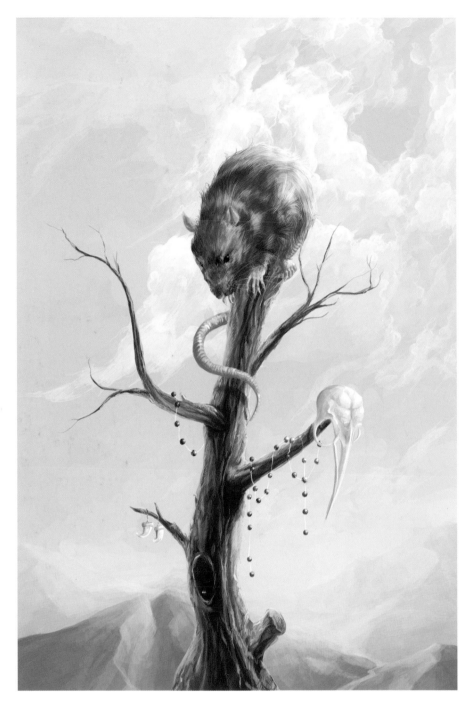

▲ *Dead Bird Tree I Love You* *Mask of Pain* ▶ ▲

Happy Sunset Birds Dance ▶

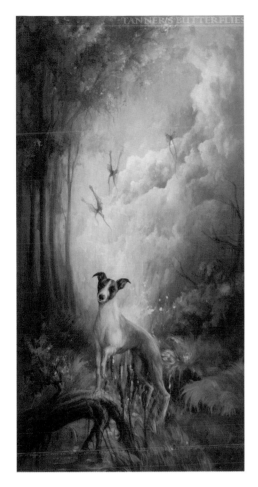

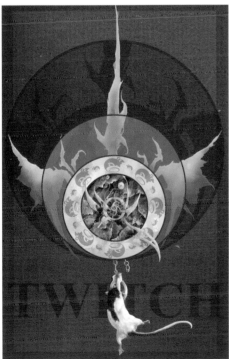

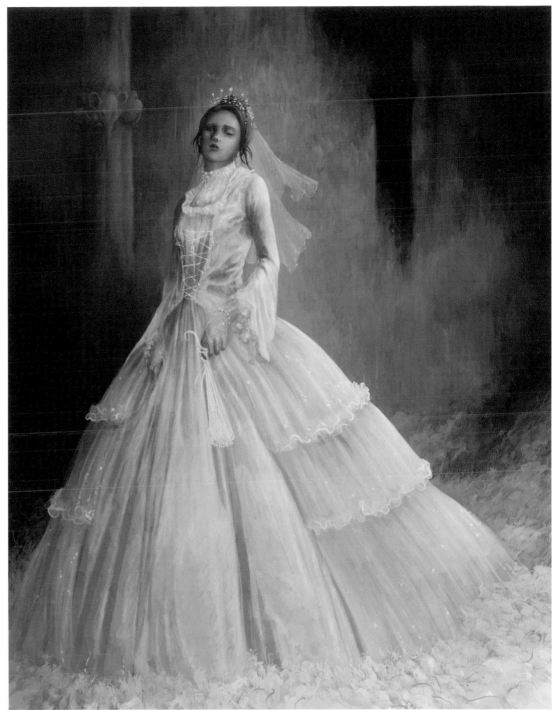

▲ ◀ Tanner's Butterflies

The Rat Queen's Wedding Party ▲

▲ Twitch!

TINA OLOYEDE

Tina Oloyede (aartika)

Tina Oloyede writes: 'I grew up in England, studied medicine in London, and then trained to become a General Practitioner. I now live with my family in the heart of rural England, and fit in my passionate hobby of fractal art around a busy home life.

'Although I've had no formal art training, I've always held a keen interest in art, particularly modern and abstract works, and enjoyed being creative. I bought my first computer in 1993, and over a few years taught myself the basics of web design, working with graphics programs and fractal art. The use and availability of modern computers has revolutionized the creative process for me, as my technical art skills have never been very good!

'Doug Harrington, who offered me a great deal of support and tuition in the early days, introduced me to fractal art in 1999. The first images I created were with Tierazon and another of Stephen Ferguson's programs, Sterlingware. I started using the shareware program Ultra Fractal (UF), written by Frederik Slijkerman, in early 2000, and now use it almost exclusively. This program combines powerful fractal-image generation with the sophisticated layering usually seen only in expensive graphics packages, and allows for a wide variation in artistic freedom and creativity. There is a huge amount of control in the hands of the artist when using UF, from deciding which formula to start with, which colouring and mapping to apply, and adjusting the parameter settings for these, to creating and editing gradients, masks and layers.

'I would not have reached the point I am now without the help of some very good friends who have been willing to share ideas, techniques, formulas and much else besides. My warmest thanks to Linda Allison, Linda Bucklin, Paul deCelle, Michèle Déssureault, Thomas and Sharon Emrich, Emily Garlick, Cornelia Heigele, Klaus-Peter Kubik, Dan Kuzmenka, Andreas Lober, Eva Lunden, Dennis Magar, Bob Margolis, Richard Molnar, Samuel Monnier, Leslie Moore, Edward Perry and Karen Trottier.'

www.aartika.co.uk

Alternate Reality
2002
Renderosity Magazine Cover Contest entry
2734 pixels x 3200 pixels
Software and platform: Ultra Fractal, Windows 98se

This image uses Samuel Monnier's Tube Julia formula, with Dennis Magar's Doodads colouring algorithm. I took inspiration from an image by fellow artist and friend Lesley Moore (Mint) in the creation of the texturing for this.

Daybreak
2001
Entry for the Spring 2001 Ultra Fractal Contest
3200 pixels x 2400 pixels
Software and platform: Ultra Fractal, Windows 98se

One of a series called *A Day at the Beach*, this was created for the Spring 2001 Ultra Fractal Contest, run by Janet Parke. The rest of the series can be seen on-line: www.parkenet.org/jp/fractals/uf/series/a0.html. This image sets out to deliberately set a scene using only fractal elements available in Ultra Fractal, as specified in the rules of the contest. I found it difficult technically, but it remains one of my all-time favourites. It is rare that I create an image with a specific purpose in mind, but the challenge of this contest proved a very valuable learning tool.

In a Spindle
2002
Personal work
3200 pixels x 2560 pixels
Software and platform: Ultra Fractal, Windows 98se

This uses Mark Townsend's Rudy's Cubic Julia and Andreas Lober's M-Gnarly Orbit Traps Distance Method.

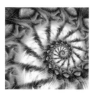

Nautilus
2001
Personal work
2560 pixels x 3200 pixels
Software and platform: Ultra Fractal, Windows 98se

This image uses Samuel Monnier's Tube Julia
formula with two of Andreas Lober's colouring
algorithms from his M-series.

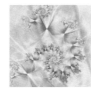

Kitalless
2002
Personal work
2133 pixels x 3200 pixels
Software and platform: Ultra Fractal, Windows 98se

A standard Julia with plenty of texture.

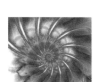

She Sells Mussel Shells
2002
Personal work
3200 pixels x 2844 pixels
Software and platform: Ultra Fractal, Windows 98se

One of four images representing the four seasons;
this one was Summer. Although inevitably very
abstract, fractal images can often conjure up a feel
of naturally occurring and living things. In this image
the colours, in particular, make me think of sea life
washed up on the shore. It uses Tube Julia, T Pure
Color-By and mt-gnarly_traps.

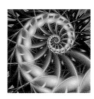

Water Sprite
2002
Personal work
3200 pixels x 2664 pixels
Software and platform: Ultra Fractal, Windows 98se

Sea Spray
2002
Personal work
3200 pixels x 1920 pixels
Software and platform: Ultra Fractal, Windows 98se

Wiggly Soapstone
2002
Personal work
3200 pixels x 1800 pixels
Software and platform: Ultra Fractal, Windows 98se

This was the first image I created using the
long-awaited Ultra Fractal 3 upgrade.

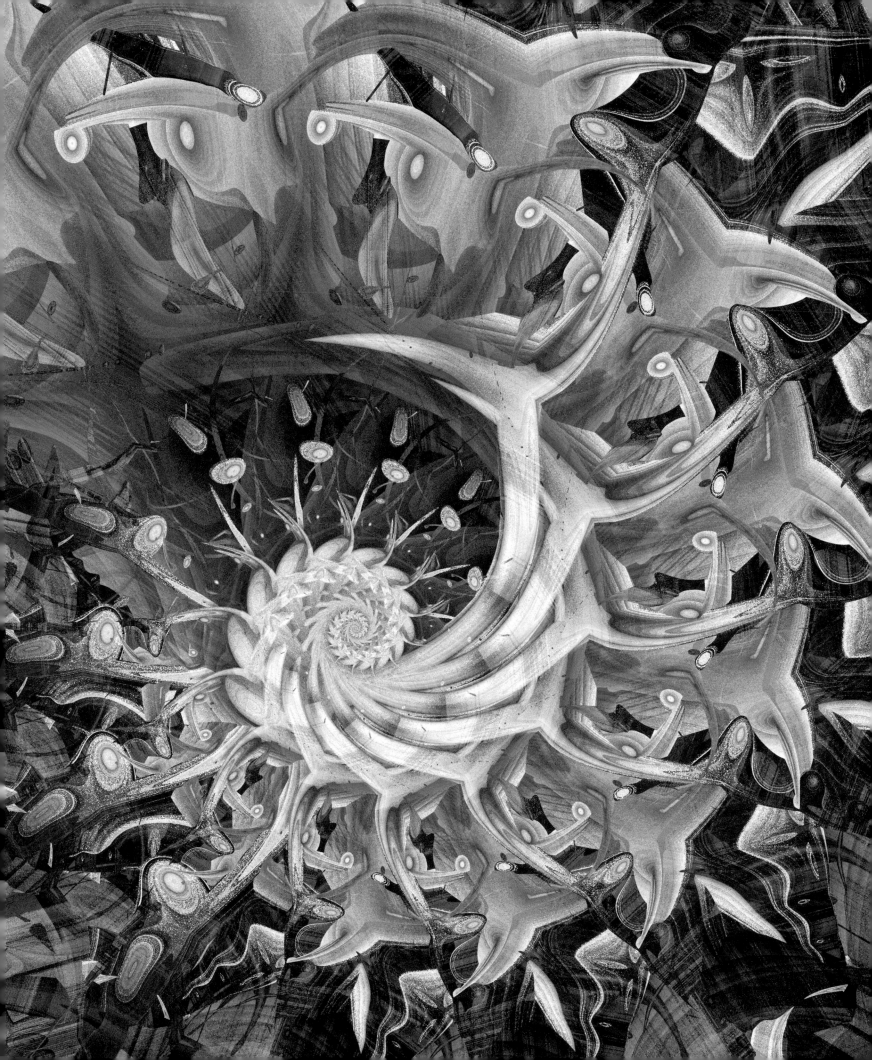

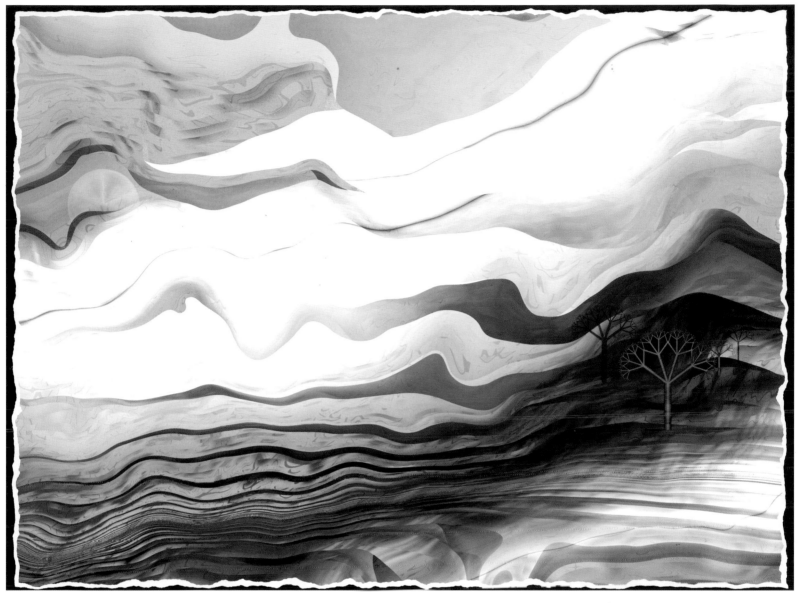

▲ *Daybreak*

In a Spindle ▶

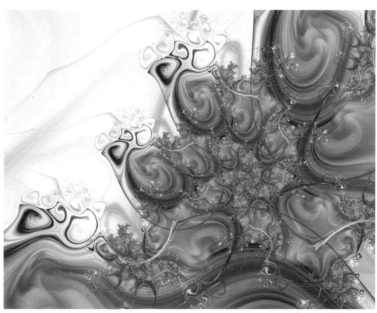

◀ *Alternate Reality*

◄ *Nautilus*

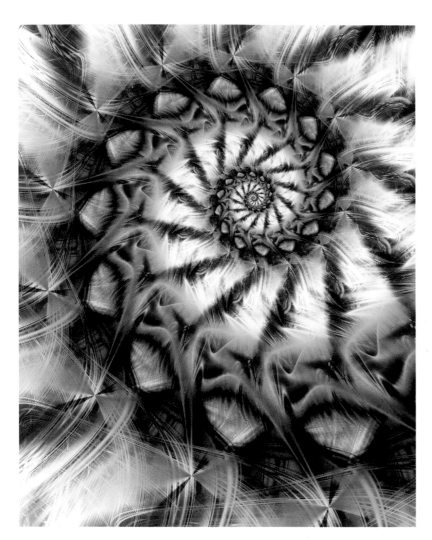

She Sells Mussell Shells ▼

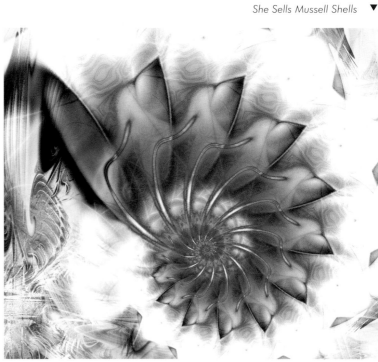

Sea Spray ▶

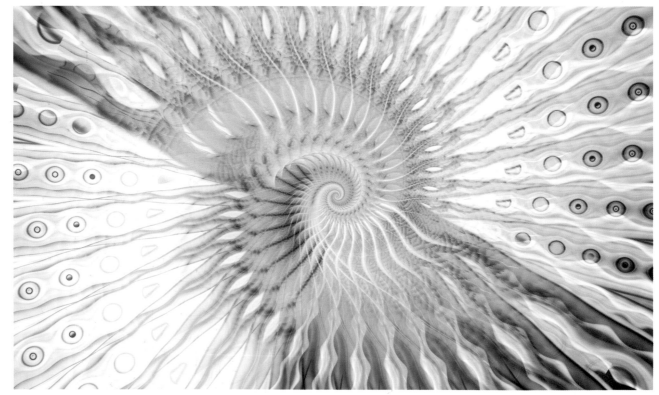

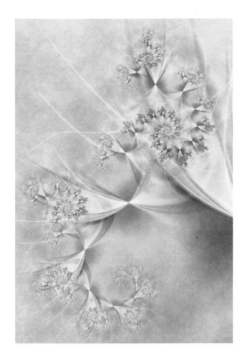

▲ *Kitalless*

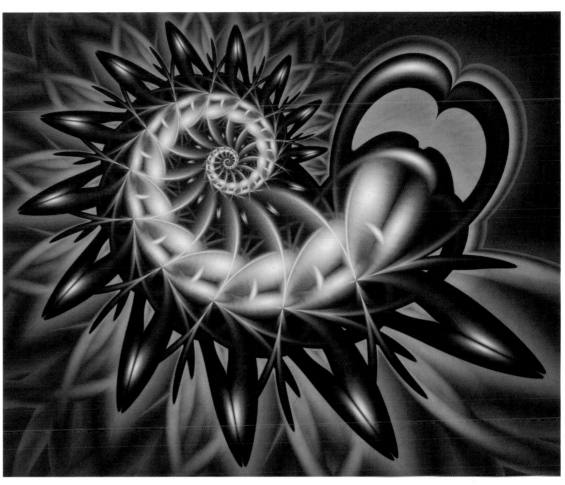

▼ *Wiggly Soapstone* *Water Sprite* ▶

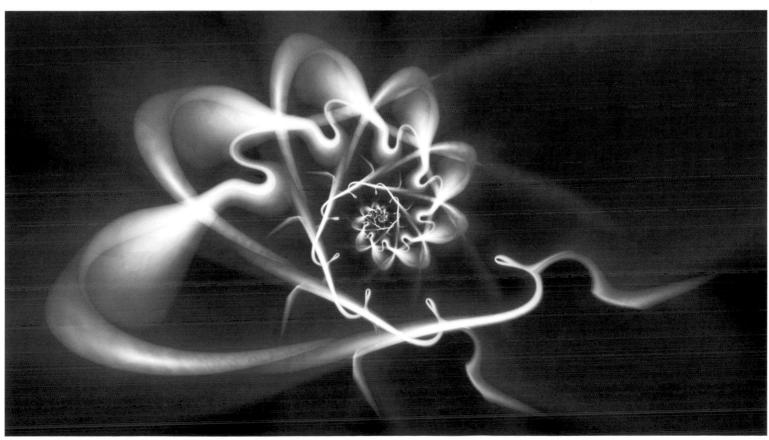

JOHN PICACIO

John Picacio

San Antonio native John Picacio combines his real-world paintings and the collage and assemblage of mixed media to communicate about the world around him. His illustration work graces the covers and interiors of major books, magazines and other media. Clients include Random House/Del Rey, Penguin Group/Roc, Tor Books, Viking Children's Books, Golden Gryphon Press and MonkeyBrain Books. In 2002 he received the International Horror Guild Award for Best Artist, and he is a four-time winner in *Spectrum: The Best in Contemporary Fantastic Art*.

He writes: 'I think the Mac is a fabulous tool, but I have no use for it as a tool for drawing or painting. I don't like the feel of a stylus on a Wacom tablet. There's no fun in that! I like making things with my hands. I like the mess of working in oils and acrylics. I like the smell of turpentine in my studio. I like the drag of a brush on gessoed masonite and illustration board. I like the accumulation of texture and the buildup of objects and paint. That's fun stuff!

'The computer is best used for making sandwiches. In other words, all of the ingredients of the illustration sandwich are created with my hands – all of the drawing, all of the painting. Sometimes I'll incorporate things I've photographed, or pieces of junk I've found. All this stuff is real-world, and for many assignments it'll get scanned or digitally photographed and brought into the computer. From there, I'll use Photoshop to arrange and integrate the different strata of the sandwich in ways that communicate what I want. So I get the best of both worlds – the unique things that only my hands can do in the real world and the infinite compositional possibilities of the digital world.'

john@johnpicacio.com
www.johnpicacio.com

Any Time at All
2003
Cover illustration for the novel by Chris Roberson (MonkeyBrain Books)
1688 pixels x 2625 pixels
Software and platform: Oils, acrylics and graphite on illustration board, Photoshop 5.0 (Mac)

This book is a collection of time-travel vignettes. Chris Roberson is an extremely gifted young writer – a force to be reckoned with in years to come. I kept this illustration simple. It's all about a temporal-spatial bridge and a mysterious young girl mature far beyond her years.

Dangerous Visions
2002
Cover illustration for the anthology *Dangerous Visions: The 35th Anniversary Edition*, edited by Harlan Ellison (iBooks)
2148 pixels x 3200 pixels
Software and platform: Mixed media on illustration board, photography, hand-built life-size wings, Photoshop 5.0 (Mac)

Ellison invited me to do a cover for the 35th anniversary edition of this ground-breaking anthology. I built the wings out of old copper electrical coil. Ellison deserves credit as a great art director: he let the illustration find its own way, but also offered the right bits of insight at the right time.

Budayeen Nights
2003
Cover illustration for the story collection by George Alec Effinger (Golden Gryphon)
3200 pixels x 2174 pixels
Software and platform: Oils, acrylics and graphite on illustration board, Photoshop 5.0 (Mac)

George Alec Effinger passed away shortly before Golden Gryphon hired me to illustrate this cover. After reading the manuscript, I wished I could have met him. I didn't want to illustrate a specific moment from the manuscript and steal momentum so instead I took a more conceptual approach. We see Marid Audran on the run in the Budayeen. A little bit of noir, Orthodox Islam, paranoia, and futurism – all at the heart of Effinger's Budayeen.

Heroes & Monsters
2003
Cover illustration for *Heroes & Monsters: The Unofficial Companion to The League of Extraordinary Gentlemen* by Jess Nevins (MonkeyBrain Books)
3200 pixels x 2323 pixels
Software and platform: Oils, acrylics and graphite on illustration board, Photoshop 5.0 (Mac)

For this I got to do my version of Alan Moore's and Kevin O'Neill's *League of Extraordinary Gentlemen*. A complete blast. I always thought Mina's pre-Feminist feminism was a ballsy move by Moore, and I let her moxie anchor the cover for the rest of the boys.

Echoes of the Great Song
2002
Cover illustration for the novel by David Gemmell (Ballantine/Del Rey)
2226 pixels x 3200 pixels
Software and platform: Mixed media, photography, hand-built props and costumes, Photoshop 5.0 (Mac)

A mixed-media free-for-all. I made all the illustrative ingredients in the real world and then scanned them in to be digitally compiled into something new in the virtual world. I made the costumes and bow myself. Great fun.

The Fantasy Writer's Assistant
2001
Cover illustration for the story collection by Jeffrey Ford (Golden Gryphon)
3200 pixels x 2174 pixels
Software and platform: Mixed media on illustration board, Photoshop 5.0 (Mac)

The image was inspired by 'Bright Morning', the final item in the collection and one of my all-time favourite short stories. I think people perceive this illustration one way when they first hold the book and then, when they've read the final story, see a whole new layer of meaning.

Things That Never Were
2003
Cover illustration for the essay collection by Matthew Rossi (MonkeyBrain Books)
1927 pixels x 2775 pixels
Software and platform: Oils, acrylics and graphite on illustration board, Photoshop 5.0 (Mac)

This collection of scholarly essays is confounding, eclectic and endlessly provocative – like a great book of riddles. It was a challenge to find a way to encapsulate the spirit of the book because it was so free-ranging in its subject matter. In the end I decided to keep it simple. Who better to embody a riddle than a sphinx?

Legend
2002
Cover illustration for the novel by David Gemmell (Ballantine/Del Rey)
2048 pixels x 3200 pixels
Software and platform: Mixed media, photography, hand-built props and costumes, Photoshop 5.0 (Mac)

Druss is the focus of this illustration and he's doing what he does best – generating massive body counts with his battleaxe. I built my own axe and weaponry – real stuff, not digital. The gladiator helmet in the lower foreground consists of a copper watering pot, a cake-frosting nozzle and the spikes from a few miniature American flags.

Two Trains Running
2002
Cover illustration for the story collection by Lucius Shepard (Golden Gryphon)
3200 pixels x 2174 pixels
Software and platform: Oils, acrylics and graphite on illustration board, newspaper, Photoshop 5.0 (Mac)

This collection revolves around the lives of hoboes on the railroad. The stories are very surreal, skilfully blending reality and imagination and blurring fact with fiction. I liked the unexpected poignancy underneath the steel and mayhem, and that quality inspired this wraparound cover illustration.

Live Without a Net
2002
Cover illustration for the anthology edited by Lou Anders (Roc)
3200 pixels x 2322 pixels
Software and platform: Oils, acrylics, graphite and ink on illustration board, Photoshop 5.0 (Mac)

A spirit of revolution and 'breaking away from the norm' pervades all eighteen stories in this anthology. Its editor, Lou Anders, was trying to 'unplug' science fiction from all of the cyberbabble – if only to provoke new questions and perspectives in an increasingly digital age. That attitude was the springboard for this cover illustration.

▲ *Any Time at All*

Dangerous Visions ▼

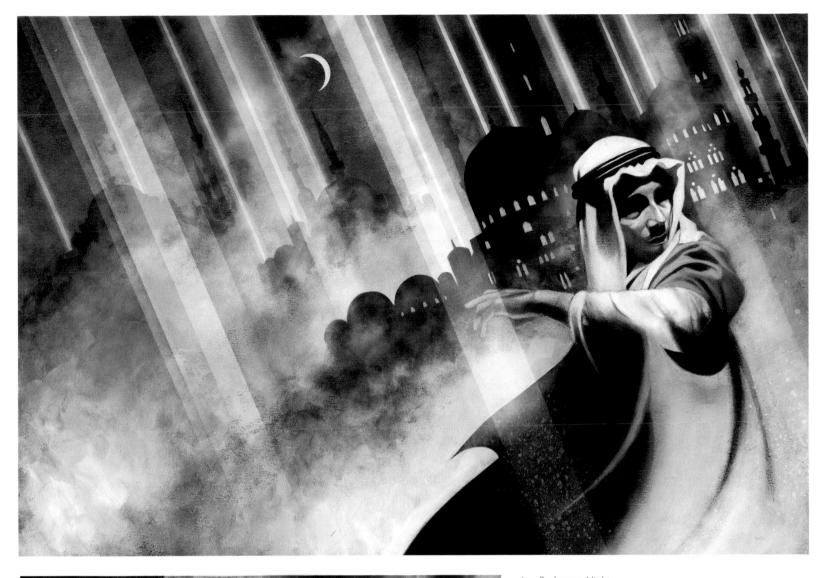

▲ *Budayeen Nights*

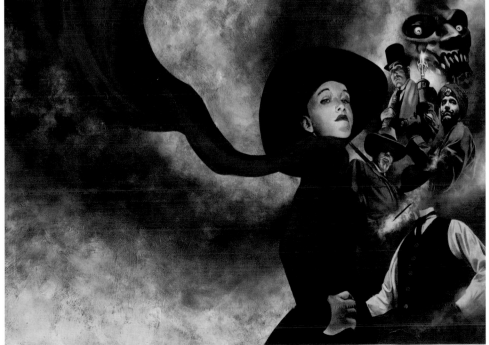

◄ *Heroes & Monsters*

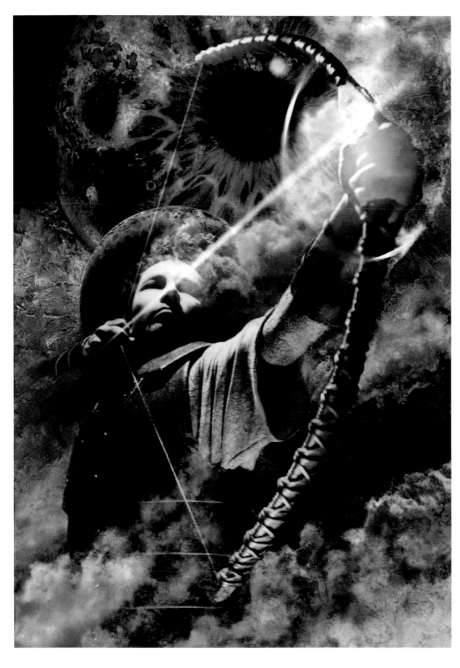

▲ *Echoes of the Great Song*

The Fantasy Writer's Assistant ▶

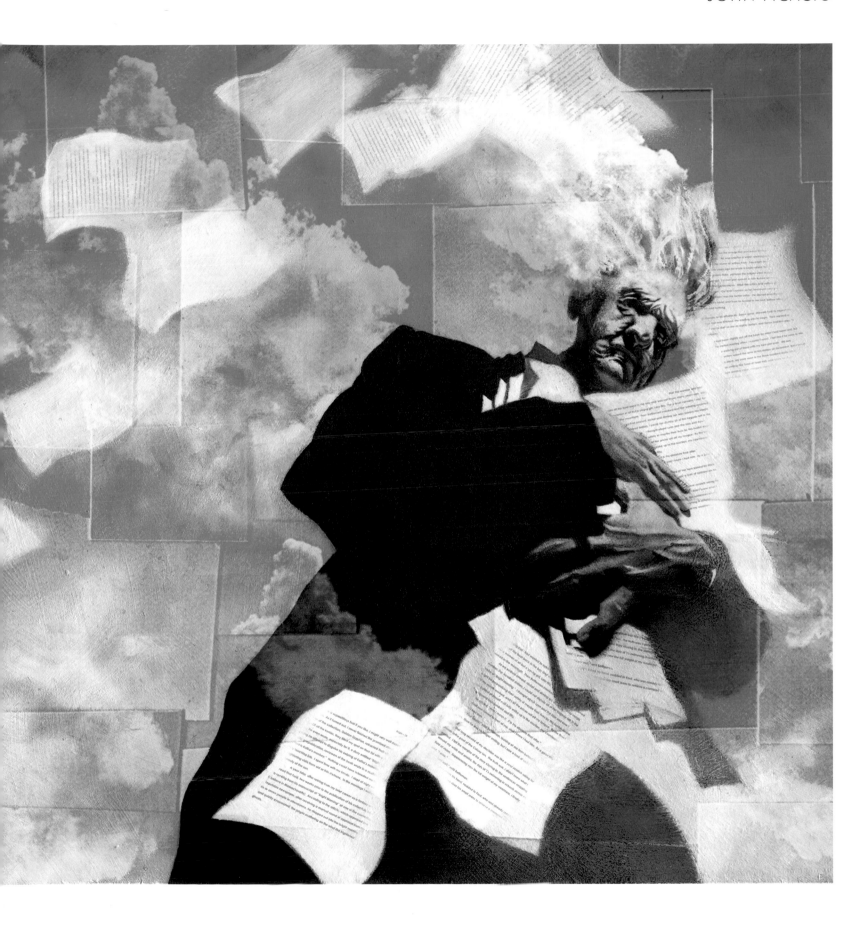

▲ *Things That Never Were*

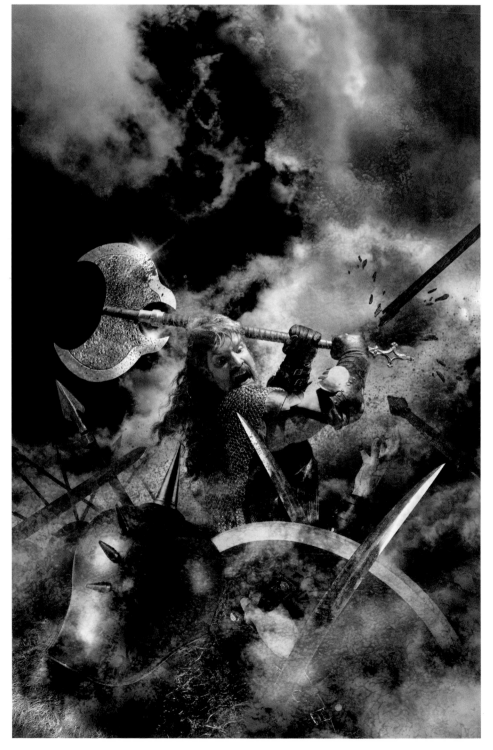

Legend ▶

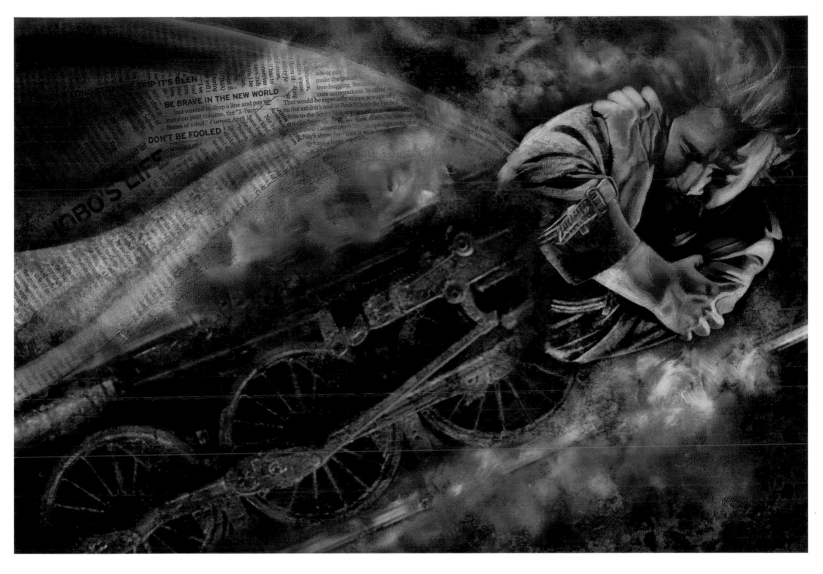

▲ *Two Trains Running*

◀ *Live Without a Net*

KEES ROOBOL

Kees Roobol (roobol)

Kees Roobol writes: 'Kees, short for "Cornelis", is in my language pronounced "Case". I'm 48, married and Dutch, though I live in the Flemish part of Belgium, working in the French-speaking part. In daily life I'm a research scientist at a pharmaceutical company, where I head a small immunology group. Our mission is to figure out what goes wrong in all kinds of nasty diseases and, armed with that knowledge, to try to develop new and better treatments. It's a fascinating job, but one that takes some 55-60 hours per week. My remaining spare time I try to divide between making images (with my computer), beating my wife (at tennis!) and travelling around to get all the textures that I need for my images.

'I have been making images since I could hold a pencil, I think, but it became more serious in high school. At the age of 17 I had to choose between art and science. I finally opted for science, since I reckoned that, while as a scientist I would still be able to make art in my spare time, the converse would be next to impossible. Art has remained a life-long hobby, though, and I have experimented with all kinds of techniques – oil paint, pastel, charcoal, pencil, photography and video. From 1995 to 2000 I went to a sort of art school (more a drawing class) in the evenings to improve my drawing skills and to learn a bit more about art theory.

'An image usually starts fairly finished in my head, and then I start the process of making all the textures and meshes I need to reproduce it. Since most if not all of my textures are photographic, Photoshop is the application I begin with. The corresponding terrains and lattices are made in Photoshop too, since the terrain editor of Bryce is a bit too limited for my purposes. Everything that cannot be made with terrains is modelled in Raydream, though a move towards Cinema 4D is planned. Poser is a nice tool as well, but I mostly use it to experiment with different poses in draft versions; for the final render I prefer real humans – friends, neighbours or actors. The nude model from art school still poses occasionally for my 3D/2D work.

'In the second phase, the entire scene is built in Bryce, and usually rendered at a 2000 by 3000 pixel resolution. The final render is enlarged to 4000 by 6000 pixels for post-production work. Once I have finished, the resemblance to the original idea is usually only marginal.

'I'm inspired by almost everything – movies, music, books, things that happen in daily life. The genre that attracts me most is magic realism, and the painter within this genre who has most influenced me is probably Carel Willink.

'In my work I try to capture a moment in time, with a lot of things that could have happened beforehand and a lot of things that might happen afterwards. I always attempt to introduce some sort of conflict or tension in the way the characters do or do not interact with each other or their environment, and also through the use of symbols for death, religion, love, loneliness, etc. I try to do this in an open-ended manner so that the viewer may find his or her own stories in my work.'

www.renderosity.com/homepage.ez?Who=roobol

The Realms of Fulfilment
2003
Personal work
3140 pixels x 4000 pixels
Software and platform: Bryce 5, Photoshop 5LE, Painter 7, Raydream 4, Mac OS9.1

Making this image dramatically increased my admiration for artists who tackle winter scenes! Textures were photographed at the presbytery of Eizeringen, Belgium, and the buildings were reconstructed with lattices made in Photoshop. Characters were photographed and imported as 2D panes. All post-production work in Painter.

The Gates of Redemption
2002
Personal work
2200 pixels x 2826 pixels
Software and platform: Photoshop 5LE, Painter 5, Mac OS9.1

Slightly different from my usual 3D stuff. The image was composited from different digital photographs and duotoned in Photoshop, with minor post-production work in Painter.

The Gathering of Fates
2003
Personal work
3600 pixels x 4585 pixels
Software and platform: Bryce 5, Photoshop 5LE, Painter 7, Raydream 4, Mac OS9.1

Textures were photographed at different locations in Belgium, Greece and France, and corresponding lattices made with Photoshop. Parts of the central building were made in Raydream. Characters were photographed and imported as 2D panes. Sky is a semi-transparent lattice with a photographic texture. All post-production work in Painter.

The Harbour of Oblivion
2001
Personal work
3368 pixels x 2392 pixels
Software and platform: Bryce 3, Photoshop 5LE, Mac OS9.1

With more than 1500 objects, this must be the most complex image I've ever made. Textures were photographed in the Archeon Historical Museum, Netherlands, and corresponding lattices were made with Photoshop. The shipwreck was made with Raydream. Characters were photographed and imported as 2D panes. The sky is multiple semi-transparent lattices with photographic textures. All post-production work in Photoshop.

The Blessing of Ignorance
2002
Personal work
2200 pixels x 3036 pixels
Software and platform: Bryce 5, Photoshop 5LE, Painter 5, Mac OS9.1

The inscription above the gate reads '*initium sapientiae timor domini*', which loosely translates as 'The fear of the Lord is the beginning of all wisdom' – hence the picture's title. Textures were photographed at different locations in Belgium, Greece and France, corresponding lattices were made with Photoshop. Characters were photographed and imported as 2D panes. Sky is a semi-transparent lattice with a photographic texture. All post-production work in Painter.

The Wisdom of Hindsight
2001
Personal work
3000 pixels x 2000 pixels
Software and platform: Bryce 3, Photoshop 5LE, Mac OS8.1, Mac OS9.1

If you look carefully at a blowup of this image you notice that the girl standing behind the second window isn't dressed properly – hence the title.

The Illusion of Happiness
2002
Personal work
2048 pixels x 2892 pixels
Software and platform: Bryce 5, Photoshop 5LE, Painter 5, Mac OS9.1

This is where I live – well, sort of. All textures were photographed at a 19th-century industrial site some six miles (10km) north of Brussels; the site no longer exists. The buildings were reconstructed with lattices made in Photoshop. Characters were photographed and imported as 2D panes. Sky is a semi-transparent lattice with a photographic texture. All post-production work in Painter.

The Revelation
2001
Personal work
2048 x 3072
Software and platform: Bryce 5, Photoshop 5LE, Mac OS8.1

The first time the nude model from art school agreed to pose for my 3D work. In the years to follow she would gather a respectable number of fans within the Renderosity community! This was also the first image of mine in which I made an entire building with lattices and photographic textures, something that would become my future style. All post-production work in Photoshop.

The Burden of Innocence
2002
Personal work
2048 pixels x 2658 pixels
Software and platform: Bryce 5, Photoshop 5LE, Painter 5, Mac OS9.1

Hopefully I didn't overdo the death symbols! Textures were photographed in the Bordeaux region, and corresponding lattices were made with Photoshop. Characters were photographed and imported as 2D panes. Sky is a semi-transparent lattice with a photographic texture. All post-production work in Painter.

The Guardians of Beauty
2001
Personal work
3000 pixels x 2099 pixels
Software and platform: Bryce 3, Photoshop 5LE, Mac OS9.1

Textures were photographed at different locations in France, and corresponding lattices made with Photoshop. Characters were photographed and imported as 2D panes. This was the first time I used a photographic sky, but here just as a 2D pane combined with a lot of spot lights. All post-production work in Photoshop.

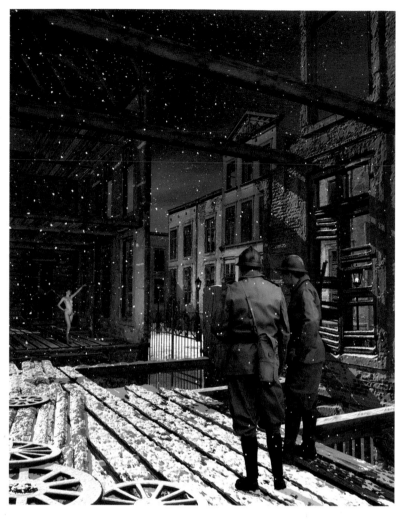

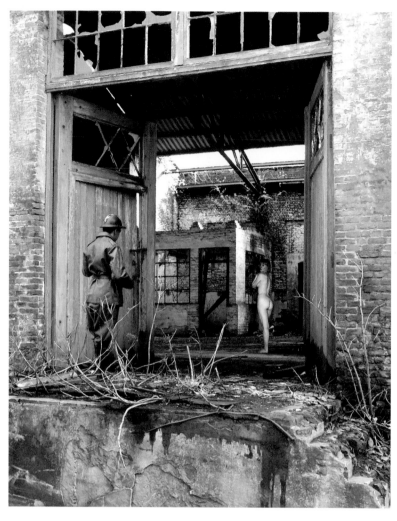

▲　*The Realms of Fulfilment*

The Gates of Redemption　▲

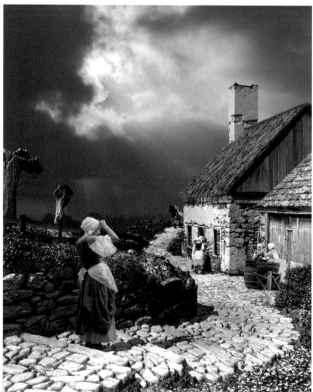

　The Gathering of Fates　▶

The Blessing of Ignorance　▶

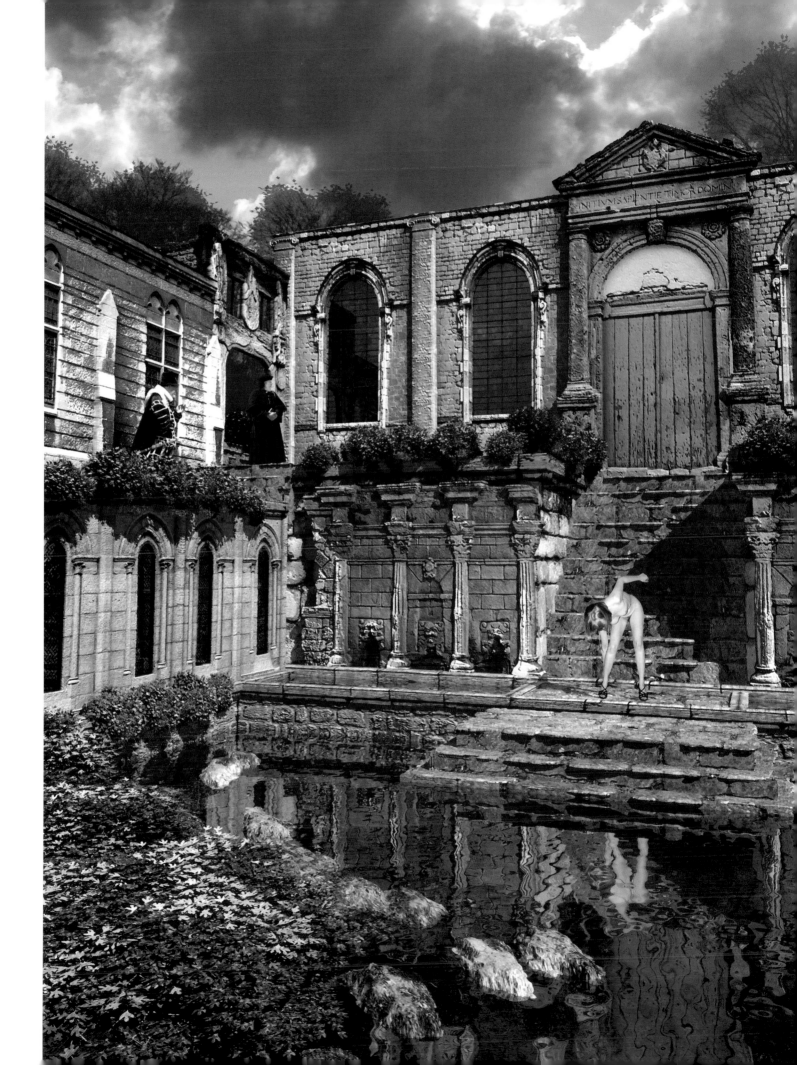

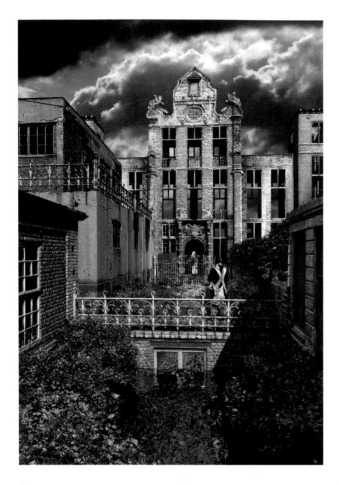

▲ The Illusion of Happiness

▼ The Burden of Innocence

The Harbour of Oblivion ▶

◀ *The Wisdom of Hindsight*

▲ *The Revelation*

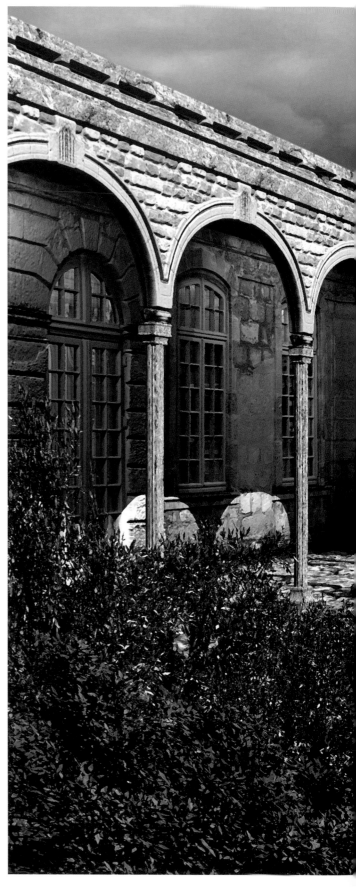

The Guardians of Beauty ▶

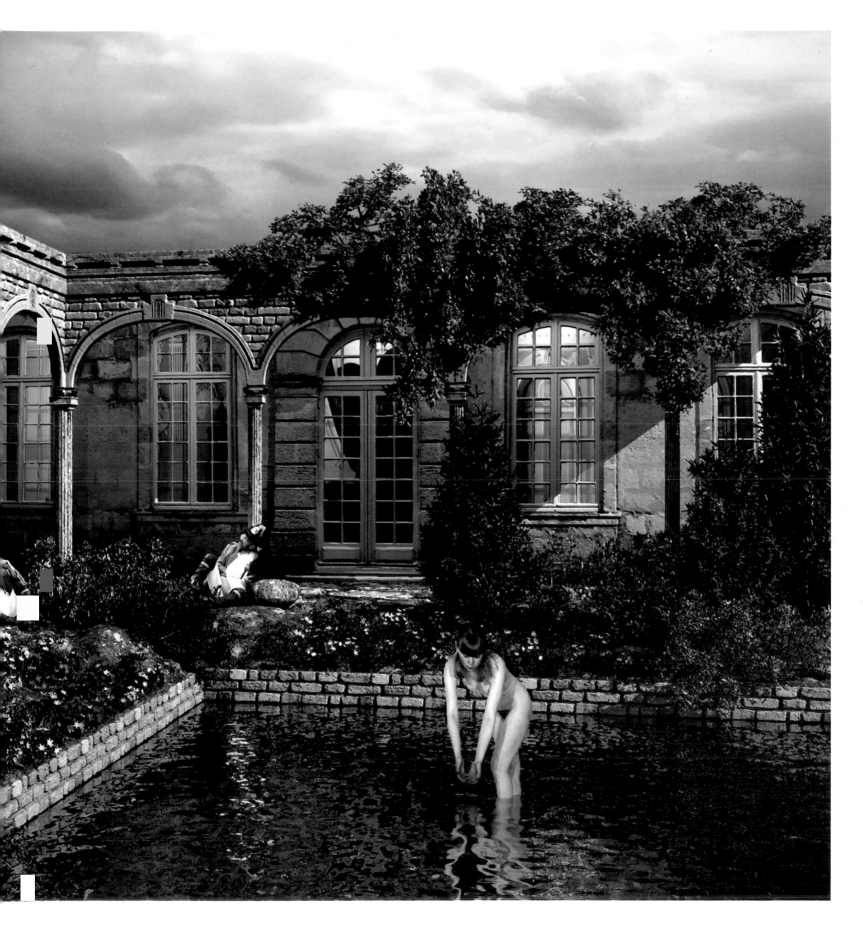

CHUCK SIEBUHR

Chuck Siebuhr (chucksiebuhr)

Chuck Siebuhr writes: 'Years ago I learned to use most of the traditional media, including pencil, pen and ink, watercolours, oils and acrylics, always striving for more detail. Later I discovered the almost extinct practice of drawing with silverpoint, which can produce a high level of fine detail – although it is unforgiving for making corrections. Working with such a strict medium taught me to see things differently and to exercise extreme care when making even the most delicate strokes. My drawing skills improved as I learned to set down only what I actually saw and not what I knew was there, no matter the subject. Strict attention to light and shadow became equally important as line and proportion. Of course, working in such a calculating manner meant that productivity took a downward turn, and there are obvious inherent limitations when working almost exclusively in the greyscale/sepia tones of silverpoint.

'Then friends introduced me to Adobe Photoshop. I immediately became a Photoshop addict, and I have rarely used traditional media since. My having learned to observe so many details proved an excellent advantage when combined with the unlimited flexibility offered by Photoshop. Now I can compose images that have detail and vibrant colour as well. The computer has allowed me to combine the best of all I learned from painting in different media, drawing and training myself to see things differently.

'I love variety, and try to make each image somewhat different from the last, although I do have a favourite style of sorts.

'One of my images (*Masque*) was chosen for the front cover of *Renderosity* Magazine, and I have been working recently with several firms on logos and architectural renderings. My preference is of course to be free simply to experiment and create art, but I also take pleasure in doing commercially oriented graphics. One of the things I enjoy most is sharing my experiences and discoveries with other artists on the Renderosity website – a great place for exchanging ideas and making new friends.

'Art has been a lifelong love affair for me, and the love is now more intense than ever. Digital imaging has, in my opinion, no boundaries other than the imagination. I intend to keep experimenting and see how far I can go.'

chuck@digitaldezyne.com www.digitaldezyne.com
www.renderosity.com/homepage.ez?Who=chucksiebuhr

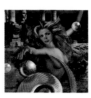

Tymewinds . . . The Dance
2003
Exhibition piece for renderosity.com
3857 pixels x 4914 pixels
Software and platform: Photoshop, Windows 2000

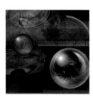

Eye of the Beholder
2002
Exhibition piece for renderosity.com
3600 pixels x 2700 pixels
Software and platform: Photoshop, Windows 2000

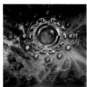

It's About Time
2003
Exhibition piece for renderosity.com
8400 pixels x 6300 pixels
Software and platform: Photoshop, Windows 2000

Exhibition piece made into an 18in x 24in
(46cm x 61cm) poster.

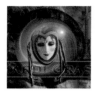

Mardi Gras
2003
Exhibition piece for renderosity.com
8400 pixels x 6300 pixels
Software and platform: Photoshop, Windows 2000

Exhibition piece made into an 18in x 24in
(46cm x 61cm) poster.

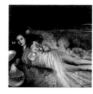

Dream Tender
2003
Exhibition piece for renderosity.com
7000 pixels x 5600 pixels
*Software and platform: Photoshop, Poser, Windows
2000*

Promotional experiment intended to be
thought-provoking for the viewer.

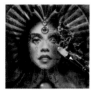

What Lies . . . Beneath
2003
Exhibition piece for renderosity.com
4900 pixels x 3850 pixels
Software and platform: Photoshop, Windows 2000

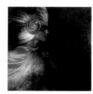

The Other One
2003
Exhibition piece for renderosity.com
8400 pixels x 6300 pixels
Software and platform: Photoshop, Windows 2000

Exhibition piece made into an 18in x 24in
(46cm x 61cm) poster.

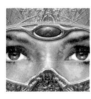

Masque
2003
Cover illustration for *Renderosity Magazine #3*
2700 pixels x 3600 pixels
Software and platform: Photoshop, Windows 2000

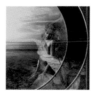

The Dream . . . or The Dreamer
2003
Exhibition piece for renderosity.com
8400 pixels x 6300 pixels
Software and platform: Photoshop, Windows 2000

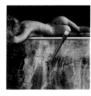

Sleeping Artist
2003
Exhibition piece for renderosity.com
4900 pixels x 3850 pixels
Software and platform: Photoshop, Windows 2000

Tymewinds . . .
The Dance

EYE OF THE BEHOLDER

Eye of the Beholder ▶

It's About Time ▼

It's About Time...

▲ *Mardi Gras*

◄ *What Lies . . . Beneath*

Reprise What Lies...Beneath

Masque ▶

▲ *Sleeping Artist*

The Dream . . . or The Dreamer ▶

▲ *Dream Tender*

The Other One ▲

ANDY SIMMONS

Andy Simmons (hobbit)

Andy Simmons writes: 'I was born in 1963 in Reigate, England, and have resided in Surrey for many years. I've always been artistic by nature, but at school I never studied art or enjoyed the way it was portrayed as a series of tedious exercises. I didn't like simply to draw an orange or a crumpled rag but instead preferred sketching fantasy castles and imaginative landscapes.

'At the age of 15 I learned to play the electric guitar. I still enjoyed doing the odd pencil sketch here and there, but music had a hold of my life for the next fifteen years. I had some professional success with a rock band in the late 1980s and in the early 1990s I released several instrumental library music albums.

'It wasn't until I was in my early thirties that I rediscovered my dormant passion for art. In 1994 I started learning traditional media, and studied portrait and landscape painting in oils. My preferred works are those of English Romantic painters, and I have closely studied the classic works of John Constable and J.M.W. Turner. I have always favoured landscapes, and studying the landscape has helped me gain the knowledge of light and contrast, which in turn has helped me achieve a degree of realism in my work.

'In 1997 I discovered computer art. I began with Bryce 3d and was instantly hooked. At first I didn't think a PC would become my everyday canvas, but thought of it more as an aid to my painting, since creating fantasy and realistic landscapes was now so easy to do. As computers developed, and more and more software and hardware became available, I put my canvas and oils aside to study computer art.

'Today I use three main programs: Bryce for scene creation, Poser for modelling figures, and Photoshop in conjunction with a graphics tablet for post-production detailing. Most of my images, themes and figures start as pencil sketches. I like to create the scene and work on composition before I take the idea into the computer.

'Most of my images are created within a few days, since I like to work fast while the ideas are flowing. Apart from the inevitable computer crashes, digital art lets my creative spirit be free in ways I never imagined.'

www.ans-graphics.co.uk

Isle of Oric
2003
Illustration for print
3000 pixels x 2250 pixels
Software and platform: Bryce 5, Windows

Dragon's Day Off
2002
Illustration for print
3000 pixels x 2407 pixels
Software and platform: Bryce 5, Photoshop, Windows

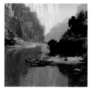

Abborlon
2002
Illustration for print
3000 pixels x 2250 pixels
Software and platform: Bryce 5, Photoshop, Windows

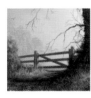

July Morning
2002
Illustration for print
2101 pixels x 3000 pixels
Software and platform: Bryce 5, Photoshop,
Wacom tablet, Windows

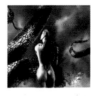

Serpent's Song
2002
Illustration for print
2120 pixels x 3000 pixels
Software and platform: Photoshop,
Windows

River Cottage
2003
Illustration for print
3000 pixels x 2275 pixels
Software and platform: Bryce 5,
Photoshop, Windows

Sea Mist
2001
Illustration for print
3000 pixels x 1908 pixels
Software and platform: Bryce 5,
Photoshop, Windows

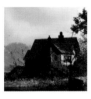

Nature's Morning
2002
Illustration for print
3000 pixels x 2063 pixels
Software and platform: Bryce 5,
Photoshop, Windows

The Caretaker
2002
Illustration for print
3000 pixels x 1950 pixels
Software and platform: Bryce 5,
Photoshop, Windows

Willow View
2003
Illustration for print
3000 pixels x 2306 pixels
Software and platform: Bryce 5,
Photoshop, Windows

▲ *Isle of Oric*

◀ *Dragon's Day Off*

Abborlon ▲

River Cottage ▼

▲ *July Morning*

Nature's Morning ▶

Willow View ▲

Sea Mist ▶

◀ *Serpent's Song*

The Caretaker ▼

AUDRE VYSNIAUSKAS

Audre Vysniauskas (audre)

After obtaining a degree in Electrical Engineering and spending 15 years working with factory information systems, in 2001 Audre Vysniauskas – better known as audre – made a major career change and became a full-time illustrator; at about the same time she became a vociferous advocate of the use of computers in creating art.

Extremely active in the digital community, she serves as a course reviewer for Siggraph; is the manager of one of the first digital sections in a major science fiction and fantasy art show (Dragon*Con); is the founder and a past Editor-in-Chief of *Renderosity* magazine; has served as Art Director of Laughing Pan Productions; is one of the principals in The Attic, 'a peculiar online community'; and is founder and co-owner of www.Attic-Wear.com <http://www.Attic-Wear.com'>. She is working with Christian Seidler, founder of the Matricism art movement, as his technical liaison, helping traditionally trained artists embrace the new technology and techniques.

Always pushing the digital envelope, she enjoys tying together varied sources in experimentational art, often incorporating fractals, photographs and other unlikely elements in her work. As an illustrator she has created numerous book covers, interior illustrations, advertising images and the like.

www.weird-art.com

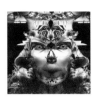

A Sophistacatus
2002
Illustration for *Deliria: Faerie Tales for a New Millennium* (Laughing Pan Productions)
4563 pixels x 5807 pixels
Software and platform: Ultra Fractal, Photoshop, Windows XP Pro

In an age when decadence is the status quo, Sophistacati push the boundaries past the extreme – replacing flesh with robotics and whatever transient fashion puts them in the proper circles – hoping to relieve, if only temporarily, their terminal boredom.

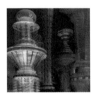

The 13th Immortal
2001
Portfolio piece
3600 pixels x 4800 pixels
Software and platform: Bryce, Windows XP Pro

Futuristic city created mostly from chess pieces. One of the fascinating things about working in digital is the amazing things you can create with ordinary objects.

Alien Embassy
2003
Illustration for music CD *Synthesia* by Persephone's Dream (Pup in a Cup Productions)
4500 pixels x 5499 pixels
Software and platform: Ultra Fractal 3.0, Windows XP Pro

Minster Hill
2001
Concept art for music CD cover for the band
Minster Hill
2800 pixels x 2200 pixels
*Software and platform: Poser, Bryce, Photoshop,
Windows XP Pro*

Morning comes to Minster Hill, where all things
are possible.

Apache Sun
2003
Portfolio piece
3000 pixels x 3440 pixels
*Software and platform: Ultra Fractal 3.0,
Windows XP Pro*

Amazing complexity and repeating patterns with
totem shapes. This beauty brings to mind the
intricate beadwork of the Native American cultures.

Split Infinity
1995
Portfolio piece
2400 pixels x 1921 pixels
*Software and platform: Fractint, Photoshop,
Windows 95*

My first encounter with fractals. This Popcorn Julia
function's movement heralds my addiction to the
beauty of mathematics. Flowing horses in infinite
complexity are what I saw.

Sleepy Hollow
2002
Illustration for *Deliria: Faerie Tales for a New
Millennium* (Laughing Pan Productions)
2700 pixels x 4808 pixels
*Software and platform: Poser, Bryce, Photoshop,
Windows XP Pro*

We are living in a magical age, an era of
blending worlds and bending minds. As old
certainties rumble, new landscapes are revealed.
Enter Deliria . . .

Grempy's Wings
1995
Portfolio piece
2325 pixels x 2925 pixels
Software and platform: Photoshop, Windows 95

In loving memory of my grandfather.

Sonic Cathedral
2001
Portfolio piece
4000 pixels x 3000 pixels
*Software and platform: Poser, Bryce, Photoshop,
Windows XP Pro*

Ghosts and memories roam the cathedrals of mind
with a life of their own. Forever, the echoes of their
passing reverberate the sweet chaotic sound.

AUDRE VYSNIAUSKAS

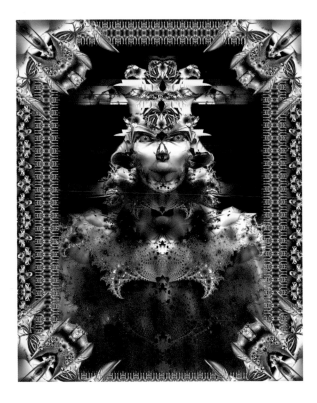

▲ A Sophistacatus

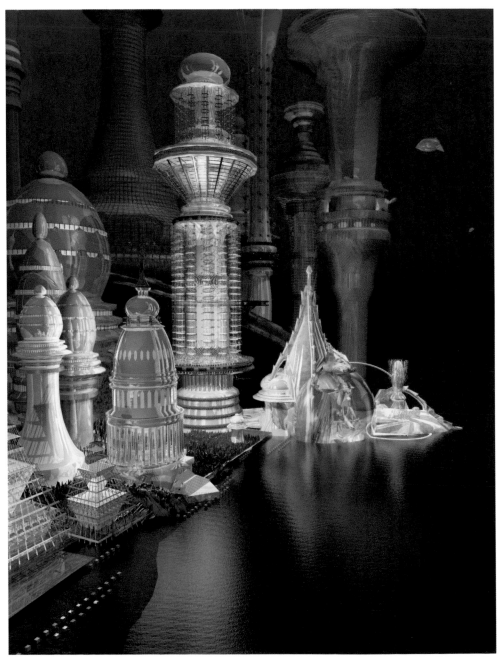

The 13th Immortal ▶

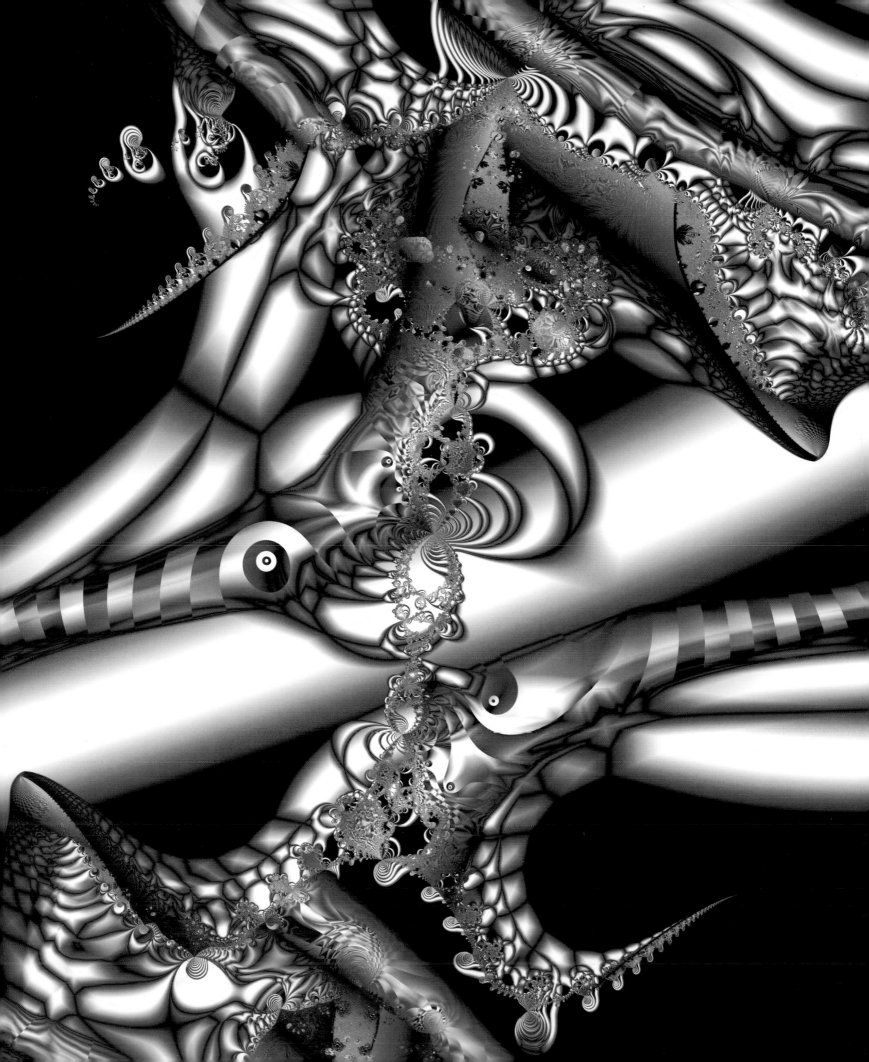

AUDRE VYSNIAUSKAS

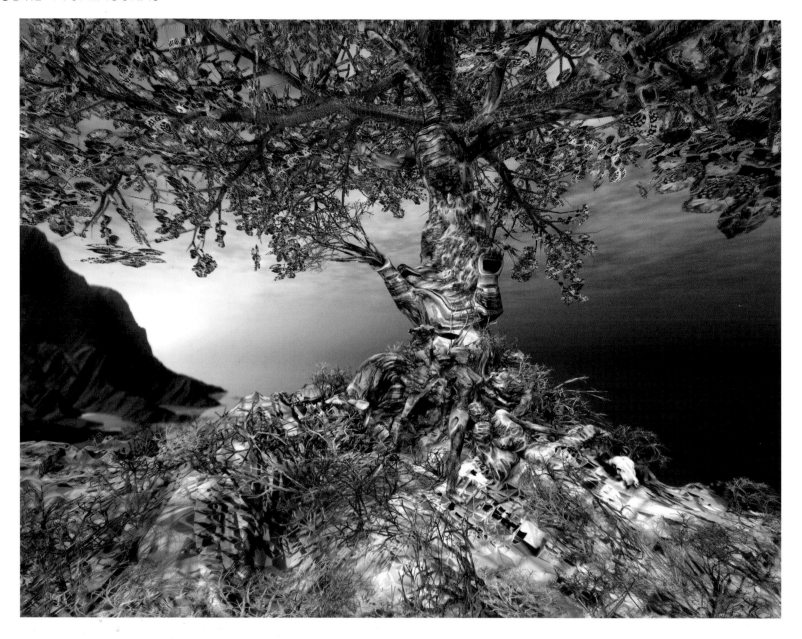

▲　*Minster Hill*

Grempy's Wings　▶

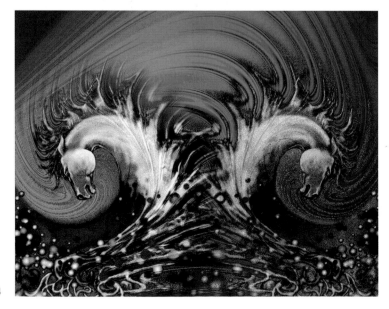

◀　*Split Infinity*

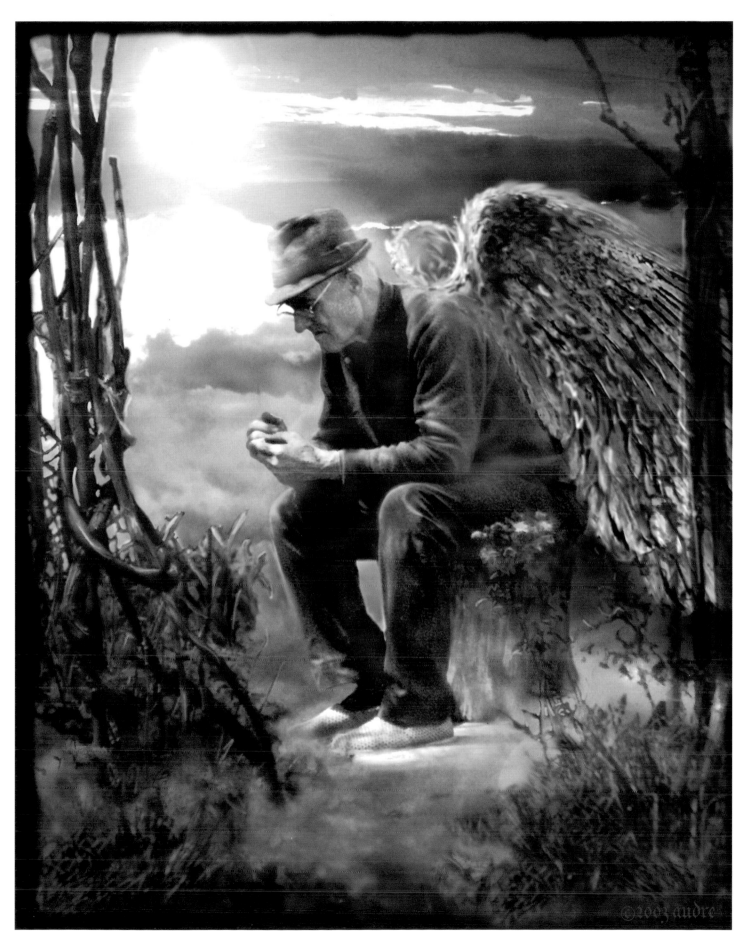

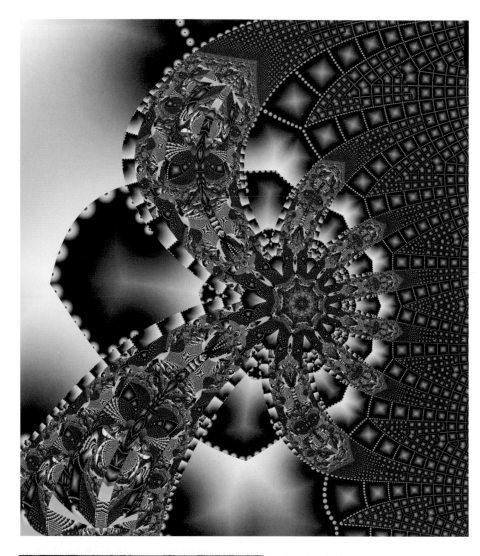

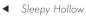 *Apache Sun*

◄ *Sleepy Hollow*

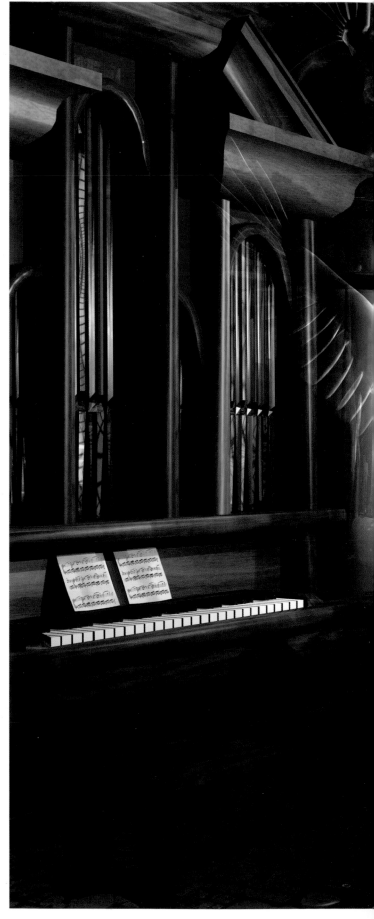

Sonic Cathedral ▶

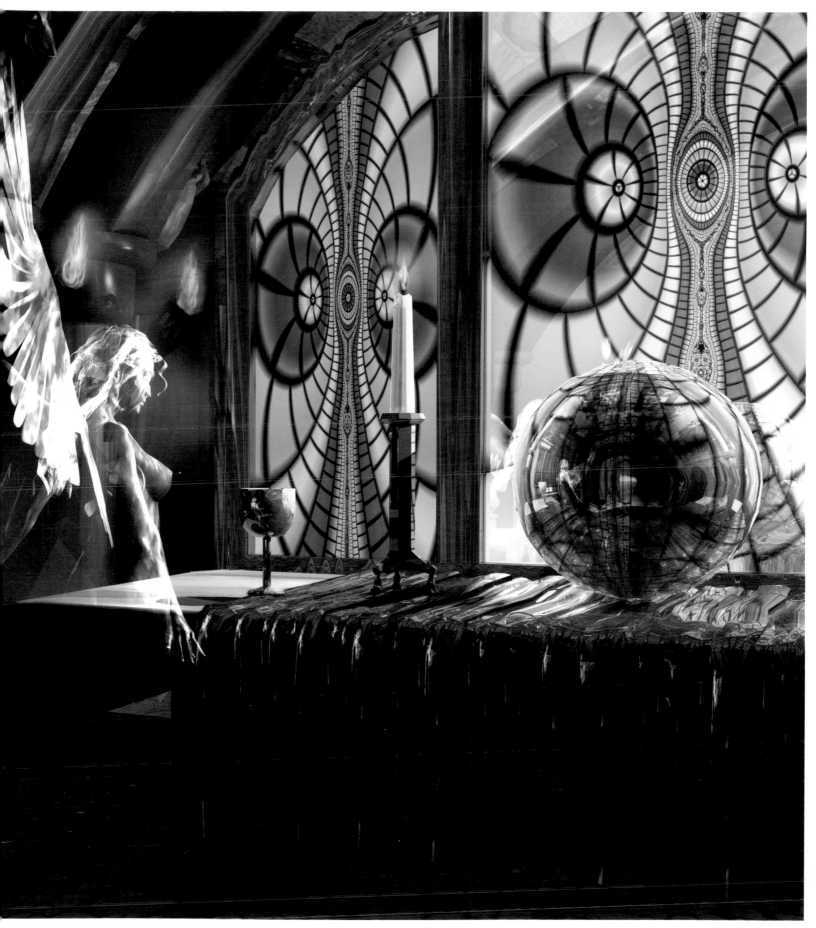

THOMAS WEISS

Thomas Weiss (beton)

Thomas Weiss writes: 'I was born in 1963 in Bavaria, Germany, and I have been drawing since I could hold a pencil. My first public art exhibition featured drawings that I did when I was 19. I have been creating 3D Computer graphics since 1999. I am a member of several different art communities on the web, my nickname in these communities being beton. Together with Alihahd I have founded the Dreamlandworks Art Gallery. You can find some of my older pictures in the book *Digital Beauties* and in the *2003 Calendar* from Taschen Verlag. A few of my works were shown at the Siggraph 2001 Conference, in the Curious Labs Corner.'

www.dreamlandworks.com

Black Lightning
2002
Personal work
2391 pixels x 3200 pixels
Software and platform: Poser 4, Bryce 5, Painter 7, Windows XP

Inspired by a picture I saw in a comic. I had a very dark and strange feeling all the while I was working on this one.

Die Muehle
2003
Personal work
2230 pixels x 3200 pixels
Software and platform: Poser 4, Bryce 5, Painter 7, Windows XP

I made the waterwheel in Bryce, just playing around. After that I got the idea for this romantic picture.

Peaceful Nature
2003
Personal work
2235 pixels x 3200 pixels
Software and platform: Poser 4, Bryce 5, Painter 7, Xfrog 3, Windows XP

This one was made for printing. I put it on the wall in a nice frame, and now you can see it in my living room!

Hexenhaus
2003
Personal work
2234 pixels x 3195 pixels
*Software and platform: Poser 4, Bryce 5, Painter 7,
Xfrog 3, Windows XP*

This cool house is a picture from the Bryce 5 CD.
I put it on a lot of Bryce rocks. In this picture I have
done a lot of post-production work with Painter.

The Last Arrow
2003
Cover illustration for a book that failed to appear
3200 pixels x 1989 pixels
*Software and platform: Poser 4, Bryce 5, Painter 7,
Xfrog 3, Windows XP*

Done as the cover for a fantasy novel; however, the
project died. I tried to make it reminiscent of the art
of Boris Vallejo and Frank Frazetta.

Monument
2003
Sketch for an oil painting
2057 pixels x 3200 pixels
*Software and platform: Poser 4, Bryce 5, Painter 7,
Windows XP*

This one I made in order to paint it in oils on
canvas later.

Stranded
2002
Personal work
2393 pixels x 3200 pixels
*Software and platform: Poser 4, Bryce 5, Painter 7,
Windows XP*

I wanted to show how lonely you can be if high
tech does not work and no helping hand is in sight.
For this picture I used a lot of stuff from DAVO
(www.beyondbent.com). *Stranded* appeared in
Renderosity Magazine with an accompanying tutorial.

Ironmine
2002
Personal work
3200 pixels x 1917 pixels
*Software and platform: Poser 4, Bryce 5, Painter 7,
Windows XP*

I was thinking of old, mystic civilizations, long lost
in the darkness of time, when I created this image.

The Trap
2003
Personal work
3200 pixels x 1997 pixels
*Software and platform: Poser 4, Bryce 5, Painter 7,
Windows XP*

Another one inspired by the work of Boris Vallejo.
The trees in the background are made from photos
taken behind my house.

Morgana, Zoom
2003
Personal work
2011 pixels x 3200 pixels
*Software and platform: Poser 4, Bryce 5, Painter 7,
Windows XP*

This is an attempt to depict a real person in 3D.
The woman is someone who lives in my
neighbourhood. When I saw the Morgana texture
from StefiZZ, I knew I had to do this picture.

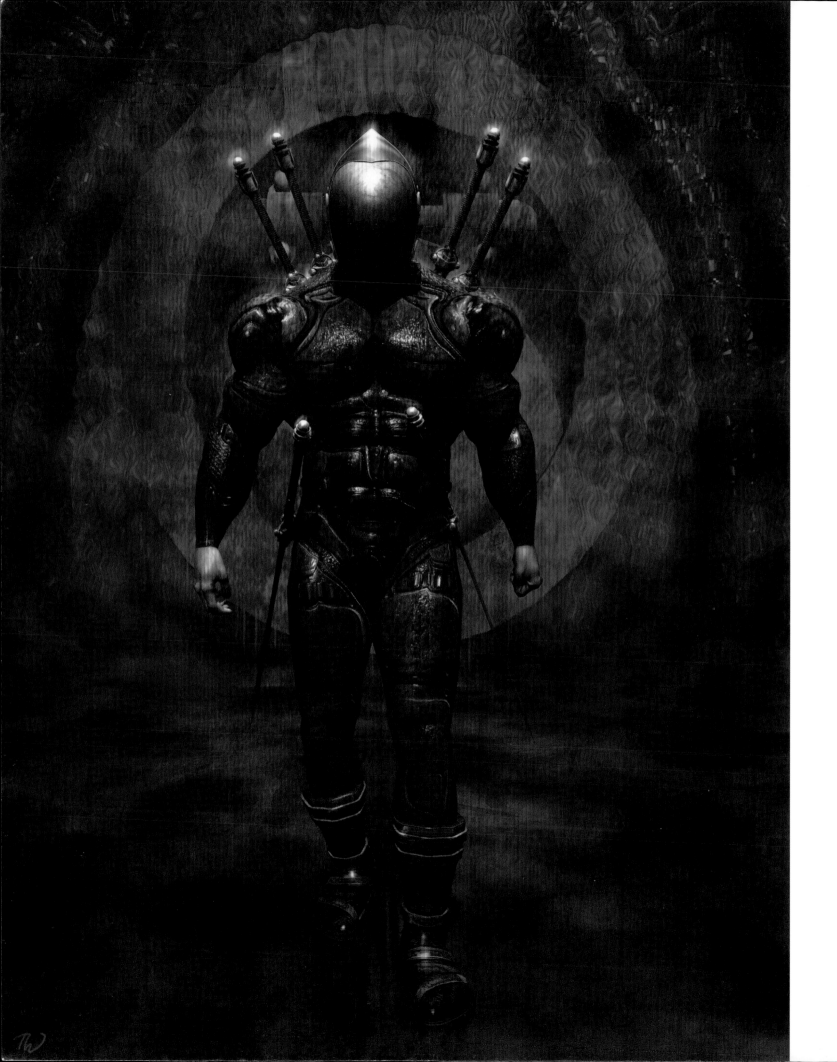

◀ *Black Lightning*

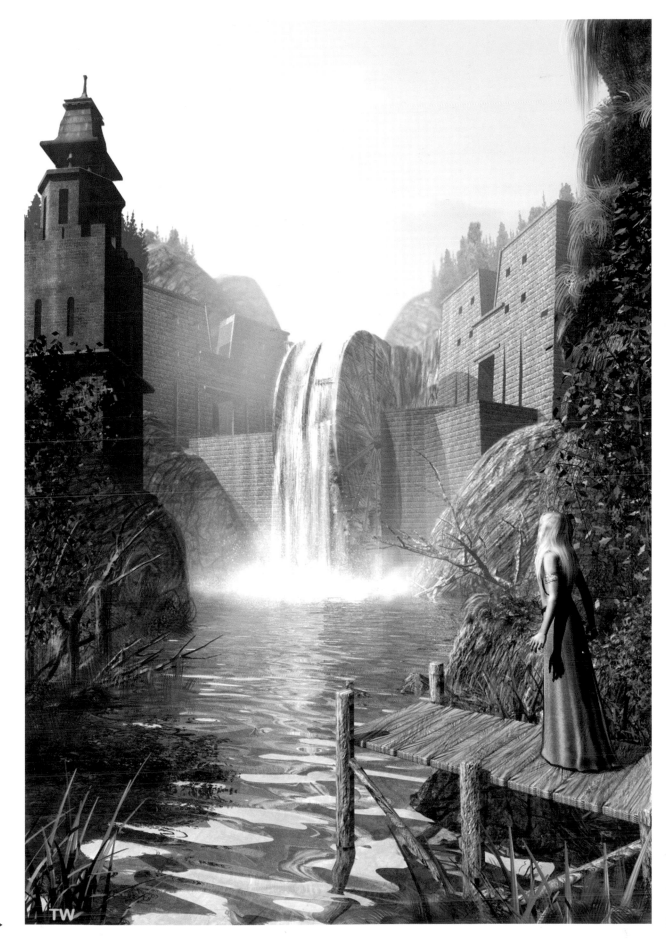

Die Muehle ▶

▲ Peaceful Nature

Hexenhaus ▶ ▲

Monument ▶ TW

▲▲ Ironmine The Last Arrow ▲

◄ Morgana Zoom

▲ *The Trap*

◀ *Stranded*

CHRISTINA YODER

Christina Yoder

Christina Yoder writes: 'I've been creating digital art since 1991. I'd always felt I was an artist, but in my youth I was heavily discouraged: art was "nonsense". In school I took many science classes so that I could practise art in the form of lab illustration. I also drew in private – I couldn't ignore the call to draw. At the age of 19 I got a job with the US Army, and became a secretary who would rather doodle than type. I started sneak-drawing on the computer so no one would see me.

'Then I got caught. I was worried I would be fired, but instead I had equipment put on my desk and was asked to draw it first in Paintbrush and then using a vector graphics program. Soon came further subjects: helicopters, hummers, tanks and more. I ceased being a secretary and became an artist.

'I took advantage of this time to get my life together and to rediscover who I really was. I put myself through art school, taught myself the major softwares and continued to create. The most important breakthrough of my life was the realization that art is not "nonsense".

'Some say digital art isn't real art, assuming ease and automation. But there's no magic wand to wave over a computer screen. Just as it takes years to master paint and pencil, it takes years to master the mouse, pixel and bézier curve. I apply everything I learned in art school to my digital art. I especially love Adobe Illustrator because it's similar to what I used in my Army days. About the only difference to me between painting and digital creation is that I don't ever have to wait for digital art to dry!'

www.dragonillus.com

Lost World Big Bad Dinos
2003
Cover illustration for DVD release of *The Lost World* (Front Row Entertainment)
2250 pixels x 3300 pixels
Software and platform: Original pencil sketch and Adobe Photoshop, Mac

A project passed across my desk that I couldn't believe: I was being asked to do the DVD cover for the original *The Lost World*! I used toy dinos as a model and drew a complex pencil sketch. I scanned the sketch and coloured over it (using Photoshop) for days. My goal was to create celluloid-looking but mean, big and bad dinos for the cover.

Deluxe Dinobots
2003
Personal work
11,000 pixels x 4500 pixels
Software and platform: Adobe Illustrator 9.0, Adobe Photoshop 7.0, Bryce, Mac

I am a rabid Transformers fan. I used to be very fond of the Dinobots back in the 1980s. After seeing *Jurassic Park* I wanted to depict the Dinobots as modern-looking dinosaurs instead of slow, lumbering machines, so I streamlined them and gave them a modern makeover. All five Dinobots are shown stomping across Cybertron's techno landscape.

Bruce Dragon
2002
Cover cameo for DVD release of *Bruce Lee's Fists of Fury* (Front Row Entertainment)
7in x 7in (18cm x 18cm) (Vector Art)
Software and platform: Adobe Illustrator 10, Mac

I wanted to dress up a cover I was working on for Front Row featuring Bruce Lee. I had created this Chinese dragon graphic for fun and had never used it. I made it look meaner, gave it a metallic appearance, and placed it as extra background art on the cover.

Ice Wyrm
2002
Personal work
11in x 17in (28cm x 43cm) (Vector Graphic)
Software and platform: Adobe Illustrator 9.0

My husband Steven and I create our own holiday cards each year. I came up with this image both for the Christmas card and as part of a series featuring Wyrms done in Illustrator. It was created entirely in Illustrator by hand using only a mouse – no tablet yet! Some say using a mouse is like painting with a bar of soap, but I've been doing it since 1993 so it's become second nature.

Maniac
2003
Cover illustration for DVD release of *Maniac* (Front Row Entertainment)
1554 pixels x 2231 pixels
Software and platform: Adobe Photoshop, Poser, Mac

I was given this DVD cover to create for an old classic movie. I wanted to capture the spirit of the film, and had a small screen-shot of the scientist examining a madman's eye. The image haunted me, so I recreated it in Photoshop using Poser as a quick aid and guide for the hand.

Maria
2003
Cover illustration for DVD release of *Metropolis* (Front Row Entertainment)
6000 pixels x 7500 pixels
Software and platform: Adobe Illustrator 9.0, Adobe Photoshop 7.0, Mac

For the printed DVD cover the image was cropped to show just the head and shoulders of the robot because a major purchaser had concerns about showing the robot's bare chest! This is my original image, enhanced with Photoshop to give it that mad-scientist-electrical-space-cadet glow.

The Phantom Planet
2003
Cover illustration for DVD release of *The Phantom Planet* (Front Row Entertainment)
1554 pixels x 2231 pixels
Software and platform: Adobe Photoshop, Mac

I rendered a classic science fiction monster by hand and had to use some creative ways to give him texture in a hurry. I used seaweeds and corals of several types as reference to create the monster's 'fronds', and some googlie eyeball toys as reference for his eyes. This was yet another project where toys became an artist's best friend!

Self Perpetuation
2001
Personal work; includes a robot dragon done for an ad campaign for a client who manufactures robotic technology
11in x 17in (28cm x 43cm) (Vector Graphics)
Software and platform: Adobe Illustrator 9.0, Mac

I got tired of seeing my technical drawings either get lost in the pages of humdrum manuals or just bringing in kill fees, so I took a robot dragon I had created for an ad, added some gears, then a conveyor belt . . . then some pulleys and some other things, and the next thing I knew I had a fully functioning dragon factory!

The Unseelie
2003
Personal work
5268 pixels x 4500 pixels
Software and platform: Adobe Photoshop 7.0, Mac

This image is based on *Tithe*, written by Holly Black. It portrays a faerie from the Unseelie court, pulling off the wings of a Seelie faerie for cruel amusement. Every time I read *Tithe*, this is one of the images that immediately seeps into my imagination.

Wedding Crest
2002
Art for wedding invitation
11in x 17in (28cm x 43cm) (Vector Graphics)
Software and platform: Original pencil sketch and Adobe Illustrator, Mac

When Steven and I decided to get married, we wanted a completely different, original invitation to go with our medieval masquerade wedding theme. I researched medieval crests and came up with a design based on two of our favourite creatures – a Lyndwyrm dragon and a silver-and-black wolf. The final artwork was printed on parchment and had sections individually hand-coloured in gold and silver ink, making each invitation an original work of art.

Lost World
Big Bad Dinos ◀

Deluxe ▶
Dinobots

▲ *Bruce Dragon*

▼ *Maniac* *Ice Wyrm* ▶

◄ *Maria*

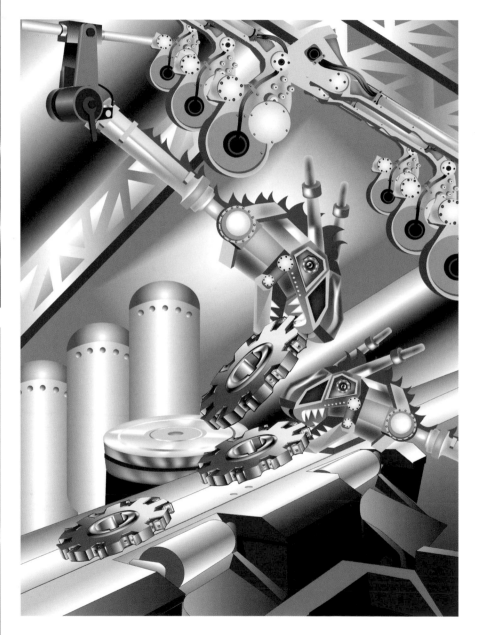

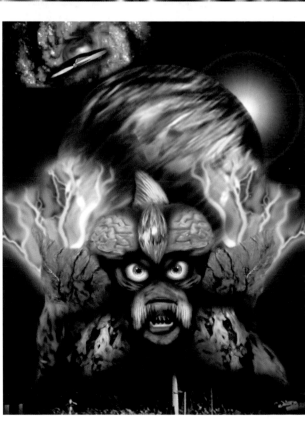

Self Perpetuation ▲

◄ *The Phantom Planet*

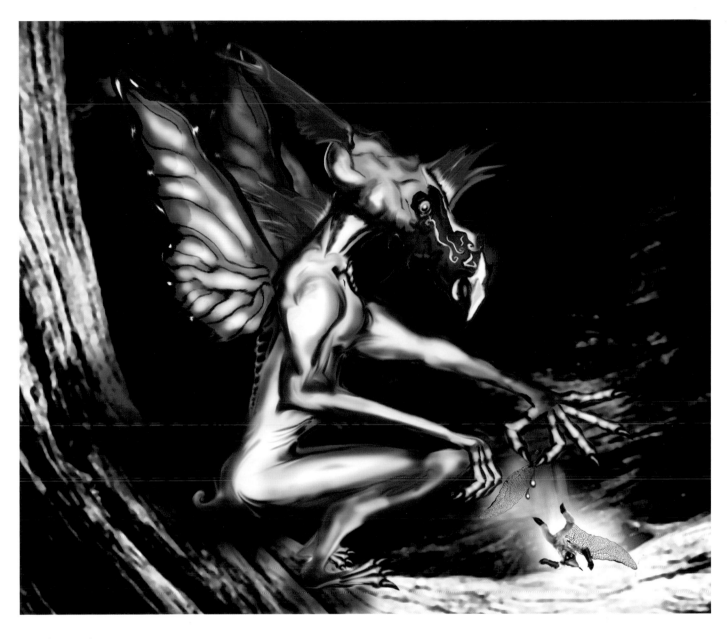

▲ *The Unseelie*

◀ *Wedding Crest*

MARCIN ZEMCZAK

Marcin Zemczak (crommcruac)

Marcin Zemczak writes: 'I was born in 1972. I didn't attend art school, and the only graphics-related subject I have studied is technical drawing. I have worked with computers for many years, and am currently a web designer for one of the larger multimedia agencies in Poland. I have always considered the creation of 3D computer-generated images a hobby.

'My experience with 3D began in 1985, in the era of machines like the ZX Spectrum. After a period of experimenting with the VU-3D program, I took a long break from 3D, during which I improved my 2D graphics skills. Working for the advertising market was another factor that improved the quality of my work, since I gained experience in composition and in managing vector and photo-editing programs. When 3D Studio came out, I used it extensively to make video clips. Lately I have focused chiefly on 3D still images, though I still work on animation as well. My work won awards from the science-fiction magazine *Nowa Fantastyka* in 1995.

'I never sketch, preferring to create the pictures directly on the computer. The main concept comes from my mind, and I start with single objects created in 3D Studio Max. The figures are often created in Poser and imported into 3D Studio Max, where I apply textures. Once the basic scene is complete and rendered, I jump into Photoshop for 2D retouching, effects and adjustments.'

www.crommcruac.com

Artificial Ladies
2002
Exhibition piece for renderosity.com
3200 pixels x 2400 pixels
Software and platform: Curious Labs Poser, 3D Studio Max, Adobe Photoshop, Windows XP Pro

The Three Graces in a future industrial environment. Are they expressing suffering or ecstasy?

Rumours About Angels
2001
Exhibition piece for renderosity.com
2400 pixels x 3200 pixels
Software and platform: Curious Labs Poser, 3D Studio Max, Adobe Photoshop, Windows XP Pro

The film *The Prophecy* was an inspiration for this work. For many generations there were rumours among the elders of the tribe about the angels who died during the Great War in Heaven. Supposedly they were buried on the great plain north of the village. A couple of brave men decided to check the truth of this legend . . .

Four Riders
2001
Exhibition piece for renderosity.com
3200 pixels x 2400 pixels
Software and platform: Curious Labs Poser, 3D Studio Max, Adobe Photoshop, Windows XP Pro

Usually when we think of four riders our first association is with the Four Horsemen of the Apocalypse, but the riders in this picture could just as easily be four warriors assembling preparatory to battle. The inspiration for this work was John Boorman's movie *Excalibur*.

Backlight
2001
Exhibition piece for renderosity.com
2400 pixels x 3200 pixels
Software and platform: Curious Labs Poser, 3D Studio Max, Adobe Photoshop, Windows XP Pro

I got the idea for this picture when I saw a tattoo album.

Morning
2002
Exhibition piece for renderosity.com
3200 pixels x 2400 pixels
Software and platform: Curious Labs Poser, 3D Studio Max, Adobe Photoshop, Windows XP Pro

New day on one of the islands near mythical Atlantis.

Strange Tunnel
2003
Exhibition piece for renderosity.com
2400 pixels x 3200 pixels
Software and platform: Curious Labs Poser, 3D Studio Max, Adobe Photoshop, Windows XP Pro

What is hiding at the end of this strange tunnel, whose walls seem to be alive? What is the meaning of the greenish glow deep within the tunnel?

Tempus Fugit
2002
Exhibition piece for renderosity.com
3200 pixels x 2400 pixels
Software and platform: Curious Labs Poser, 3D Studio Max, Adobe Photoshop, Windows XP Pro

'Time flies' – an allegory inspired by the work of Wojtek Siudmak.

Jedediah Crane
2003
Exhibition piece for renderosity.com
2400 pixels x 3200 pixels
Software and platform: Curious Labs Poser, 3D Studio Max, Adobe Photoshop, Windows XP Pro

The crazy squire who once lived among the hills surrounding H.P. Lovecraft's Arkham. Nobody knew what happened on his estate, but there were all sorts of frightful stories . . .

The Follower
2001
Exhibition piece for renderosity.com
2400 pixels x 3200 pixels
Software and platform: Curious Labs Poser, 3D Studio Max, Adobe Photoshop, Windows XP Pro

I decided to create illustrations on the theme of one of my favourite films, *Blade Runner*: constant night, constant rain. Is the woman in the foreground an android being tailed by a law officer? Or is the man an android who has just been detected by the police patrol?

The Bone Chair
2002
Exhibition piece for renderosity.com
2400 pixels x 3200 pixels
Software and platform: Curious Labs Poser, 3D Studio Max, Adobe Photoshop, Windows XP Pro

The very first version of this illustration was a collage of computer graphics and photography. Inspired by the paintings of H.R. Giger, I decided to recreate pictures using only 3D programs.

MARCIN ZEMCKAK

Backlight ▶

▼ *Romours About Angels*

▲ *Artificial Ladies*

Four Riders ▶

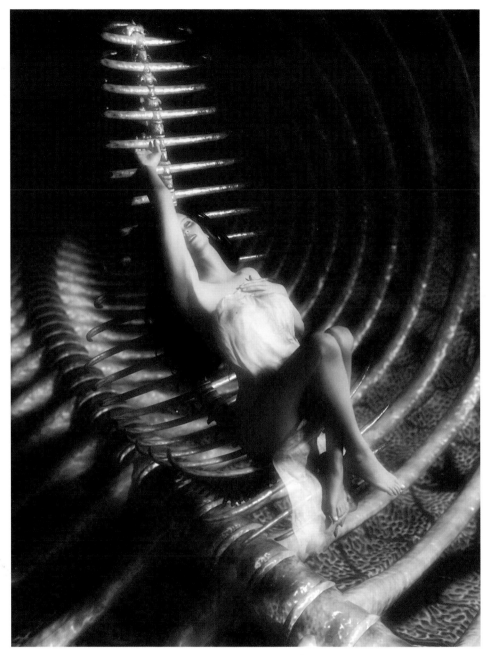

▲ ◄ *Strange Tunnel*

The Bone Chair ▲

◄ *Jedediah Crane*

Morning ▶

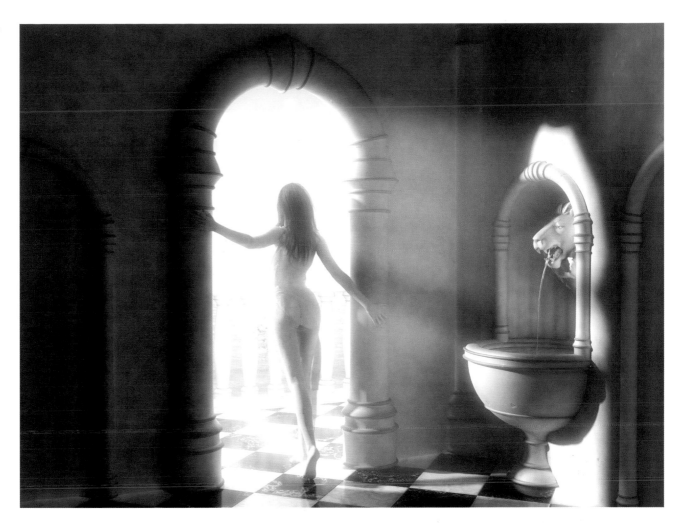

▼ *Tempus Fugit*

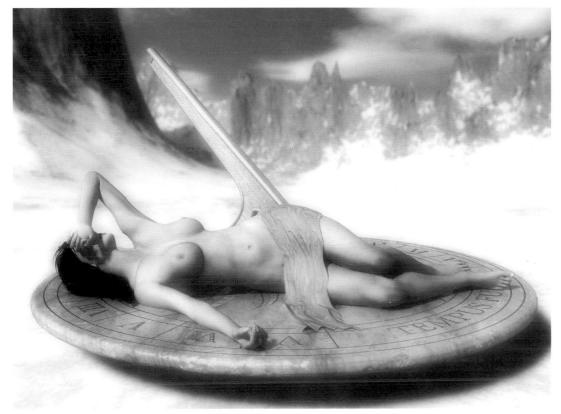

▲ *The Follower*

ABOUT RENDEROSITY.COM

Most of the artists whose work is celebrated in this book are active members of the Renderosity online art community, which is to be found at www.renderosity.com. The authors have acknowledged elsewhere in this volume the help of the administrators at Renderosity, but would like to take this opportunity of doing so again.

If, inspired by the glorious images in the preceding pages, you would like to become part of the Renderosity community yourself, you might find these notes useful. They've been contributed by Tammy Choate, Renderosity's Business Development Officer.

Our Mission

The mission of Renderosity is to create a thriving, productive environment that encourages an atmosphere of community, respect, collaboration and growth for graphic artists of all backgrounds.

History

Renderosity was born as an online community in December 1998; the name 'Renderosity' was created and voted upon by the online community itself. As the 2D/3D graphic-arts industry was exploding worldwide, there had become a need for a medium of communication that could link this diverse international group. Renderosity filled that need, and today it is the largest online community in the world for 2D/3D graphic artists.

Community

The Renderosity community is made up of members who have a passion for helping others learn, share and grow in 2D/3D art. The participation and interaction among members has made this site a second home for many, to the extent that members often consider the friends made here as extended family! Renderosity is a very interactive community, with forums, chats, content and a marketplace where members can sell their original 2D/3D products.

Many new features have come about as a direct result of member feedback. These include:

• *Free stuff*. Works are shared to advance the skills of others.
http://www.renderosity.com/freestuff.ez
• *Forums*. These are staffed with moderators who have a particular knowledge and expertise. Members help other members through teamwork.
http://www.renderosity.com/forums.ez
• *Art Gallery*. Artists can share their artwork and writings and receive feedback.
http://www.renderosity.com/gallery.ez
• *Tutorials*. 'How To's' that detail the steps for creating art or particular effects.
http://www.renderosity.com/tut.ez
• *Chat*. Immediate communication with other members.
http://market.renderosity.com/chat.ez
• *MarketPlace*. Buying and selling 2D/3D products.
http://market.renderosity.com/marketplace.ez
• *Contests and challenges*.
http://www.renderosity.com/tut.ez
• *Learning about others with similar interests*.
http://www.renderosity.com/members_overview.ez

Renderosity's members are very involved, and actively participate in all areas of the community. Whether they need technical information for the software they use, want to socialize in the Virtual Tavern or duke it out as a Render Warrior, our members are catered for. The community is sensitive to issues such as copyright regulations for all members, and discourages requests for illegal products. Our Terms of Service offer a time-tested code of conduct that regulates member activity for the benefit of all.

MarketPlace

Renderosity's MarketPlace provides a venue for artists to market and sell their 2D/3D graphic creations. The MarketPlace has a large and diverse product selection. Open to all Renderosity members, it provides a proven brokerage program for artists interested in selling their products. The community's large membership base allows artists access to a huge distribution channel for their products.

Each product undergoes testing before being released, and must match the MarketPlace's submission criteria before it is offered for sale. MarketPlace products are used daily for a variety of projects, ranging from personal artwork to commercial commissions.

Membership

Membership is free. At the time of writing, Renderosity has over 185,000 members, representing over 150 countries and many different languages and cultures. Members come from many different professional backgrounds; they include newbies, advanced artists, writers, publishers, software specialists, educators, moviemakers and people from the music industry.

Team

The Renderosity team comprises many talented people with expertise in artistic skills, business practices and internet development. Our online moderators manage the forum environments and member needs. Administrators lead the community by working with moderators and members to provide an environment of open communication and improvement.

The expertise on offer includes areas of 3DS Max, Adobe Photoshop, AMAPI 3D, Amorphium, Bryce, Carrara/Raydream, Cinema 4D, JASC Paint Shop Pro, Lightwave, MojoWorld, Painter, Poser, Poser Technical, Rhino 3D, Strata 3D, Terragen, TrueSpace, Vue d'Esprit, WorldBuilder, Xfrog, 2D graphics, 3D applications, 3D/2D animation, hardware/technical, HTML and web scripting, photography, Poser Python scripting, copyright issues and more.

We would like to send a special thankyou to all members, merchants and staff of Renderosity for making it the place it is today. Congratulations to all the Renderosity artists highlighted in this book!

INDEX OF ARTISTS AND WORKS

Page numbers in **bold** refer to illustrations

ACKNOWLEDGEMENTS

Audre Vysniauskas's thanks go to:
My parents, Albina and Jonas, for teaching me it's all right to be different; John Grant (my cantankerous bearded fairy godfather) for not letting me quit and having faith in me when I didn't; and Ray, my long-suffering husband, for continuing to live with me in spite of my cyber addiction.

John Grant's thanks go to:
My co-author, audre, for her unflagging enthusiasm (even when I had to flag it a bit) and for her friendship; and my wife Pam, not just for tolerating me – a task at which saints and angels might quail – but also, more specifically, for the help she so willingly gives me on all my books (*je t'adore, moi non plus*).

Both authors would like to thank:
All the artists who have contributed to this volume, and who have made its compilation such a joy; Bogna Hutchinson, who provided us with some desperately needed translations at a moment's notice; Pamela D. Scoville, who did likewise with technical assistance; the people at Renderosity.com (especially Tammy and Tim Choate), who gave us tremendous encouragement and much practical help; our designer Malcolm Couch, who has as always created a visually stunning package while grumbling about us hardly at all, really; and Cameron Brown, our publisher, who breathed life into this project and whose support has been both constant and admirable.